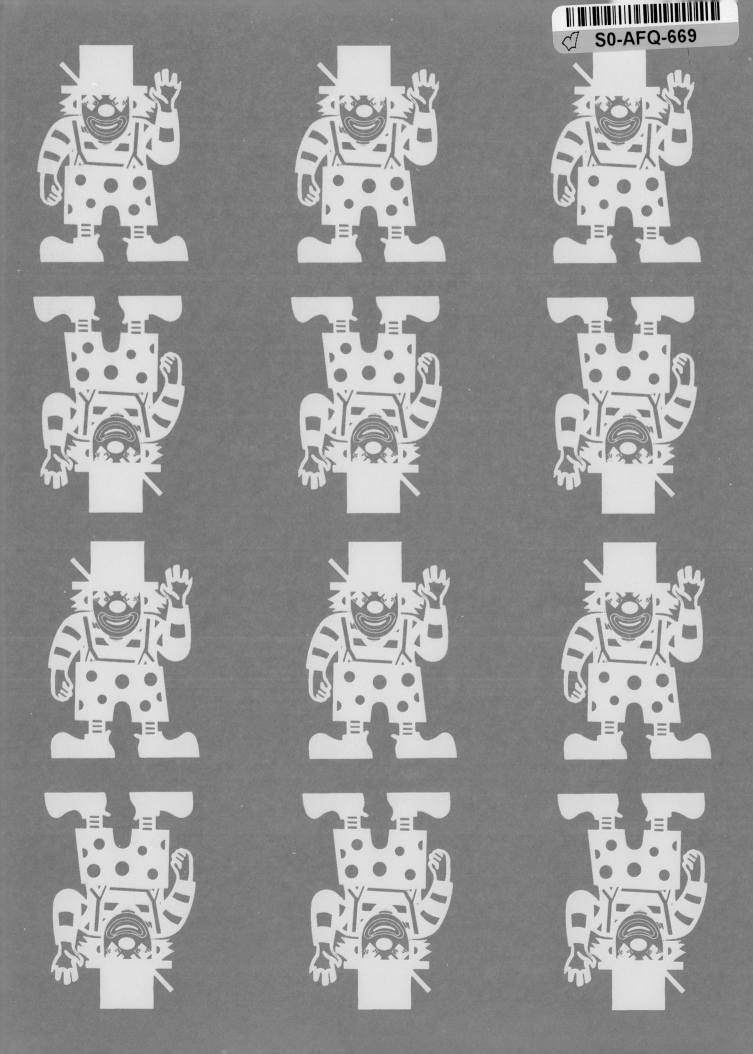

# KRAFTS FOR KIDS

# Paint

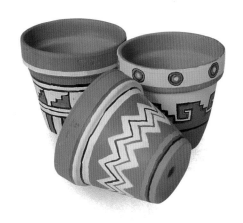

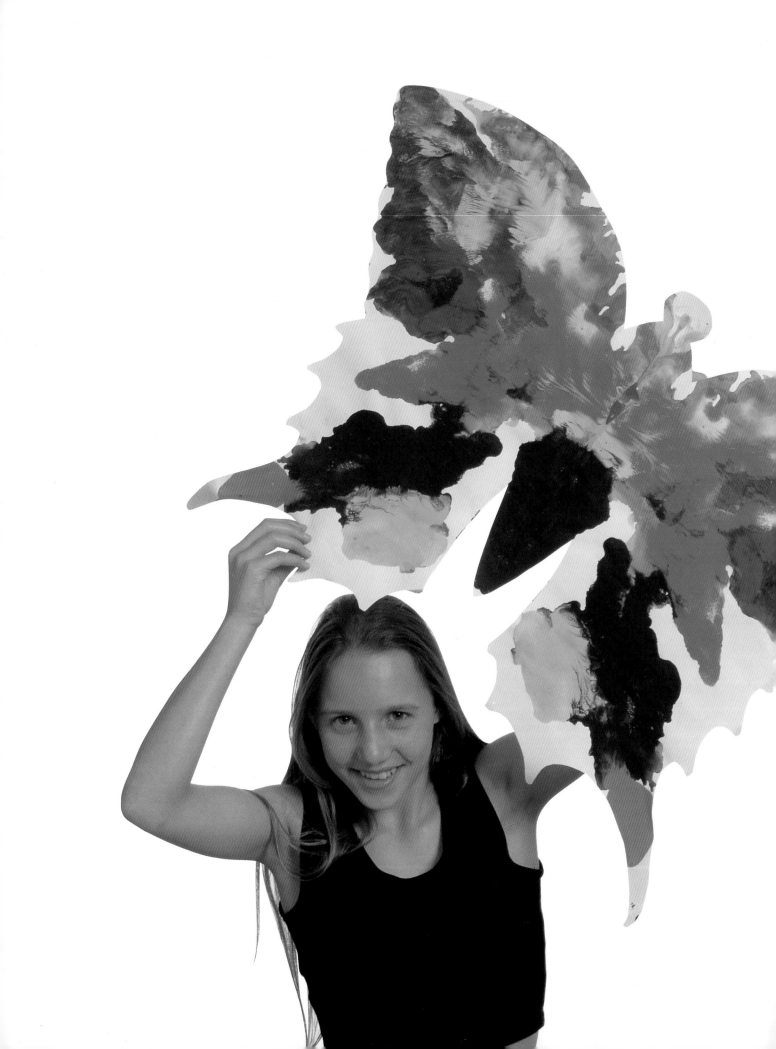

# KRAFTS FOR KIDS

# Paint

Tony Smart

CHARTWELL
BOOKS, INC.

**A QUINTET BOOK**

Published by Chartwell Books
A Division of Book Sales, Inc.
114 Northfield Avenue,
Edison, New Jersey 08837

This edition produced for sale in the U.S.A.,
its territories and dependencies only.

ISBN 0-7858-0621-0

This book was designed and produced by
Quintet Publishing Limited
6 Blundell Street
London N7 9BH

Creative Director: Richard Dewing
Designer: James Lawrence
Project Editor: Clare Hubbard
Editor: Jennet Stott
Photographers: Paul Forrester and
Colin Bowling

Typeset in Great Britain by
Central Southern Typesetters, Eastbourne
Manufactured in Singapore by
Bright Arts Pte Ltd
Printed in China by
Leefung-Asco Printers Ltd.

**ACKNOWLEDGMENTS**
Special thanks to the models: Clio Brown,
Spencer Dewing, Victoria Dewing, and
Tom Lolobo.

**DEDICATION**
To Neta Smart, for her encouragement,
advice, and practical involvement through-
out the making of this book.

**PUBLISHER'S NOTE**
Children should take great care when completing
these projects. Certain tools and techniques, such as
craft knives and using the oven, can be dangerous
and extreme care must be exercised at all times.
Adults should always supervise while children work
on the projects.
As far as methods and techniques mentioned in this
book are concerned, all statements, information, and
advice given here are believed to be true and
accurate. However, the author, copyright holder, and
the publisher cannot accept legal liability for errors
or omissions.

# Contents

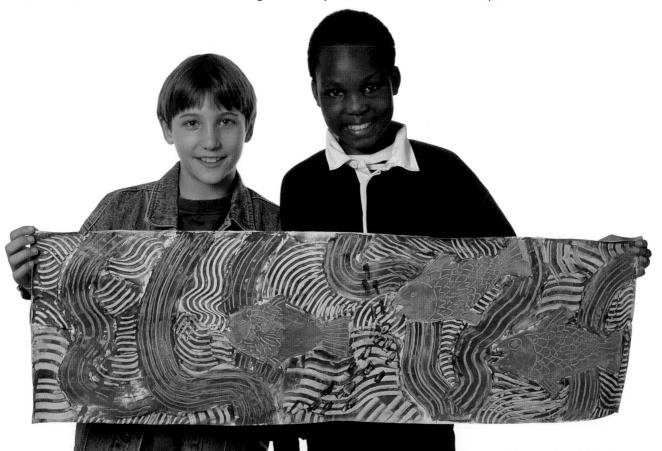

# Introduction

Using paint is fun, and we have chosen plenty of projects to help you explore its qualities of color and texture. You will find lots of different experiments and ways of applying color, and we have included ways to use your results in things to make, with clear, step-by-step pictures for you to follow. It is nice to enjoy making things. To be able to give the things you have made to your family and friends makes it even better.

Read through each project before you start, so that you see what you will need and what is involved. To highlight safety, some of the photographs are bordered with red warning triangles, and the instructions are written in bold underlined text. You should make sure there is an adult present as **these steps involve the use of sharp knives, hot surfaces, or other things which could easily harm you**. There are a few safety rules and methods of working you should know. Read the next few pages before you get to work.

You will find that painting can give you hours of pleasure and become an interest for life.

## SAFETY FIRST

The only rules that apply are safety rules. Some of the projects involve materials or processes that could be dangerous if they are misused. We have highlighted them throughout the book.

Be sure to:-
☞ follow the instructions found on the packaging of materials.
☞ be very careful when using scissors, craft knives, or other sharp items of equipment.

☞ be very careful if matches, an oven, or hot water are needed. Be sure the oven is switched off after use and that matches are fully extinguished.
☞ be very careful with liquids. Some can be dangerous. Read the precautions on the container. Avoid spillages. Wash any splashes off the skin immediately with water.
☞ keep your working surface neat and uncluttered.

## ABOUT THE PROJECTS

See these projects as just beginnings. All of them can be taken further. Once you have found out how to do a particular technique, then use your own ideas for subjects. Always choose things that you are interested in.

These projects were selected because they do not rely too much on drawing skills, although of course they all contain an element of drawing. It is a good idea to get yourself a sketchbook. It does not need to be large, but a bound one is best. Use it to note down your own ideas and thoughts (they are easily forgotten) and to draw from nature, the world about you, your friends, your home. Anything and everything is useful to help you learn and to feed and inspire your imagination. See what other artists are doing. Talk with your friends and swap ideas. Go to local art galleries. Take out books about famous painters from the library.

Young artists often have expectations of their work and they become disheartened when the results fail to match up. It is nice to be surprised by your own work. See the projects as experiments that can be developed. The more projects you do, the better you will get, and so the more you will enjoy doing them.

**Set your own creativity free.**

## TOOLS AND EQUIPMENT

We have kept the materials used in the projects at a simple level. They can be bought at art and craft stores, or from art departments in large stores, stationery stores, or toy stores.

All the paints and inks, etc., are water soluble. You only need water to mix with your paint, wash your brushes, and clean your rollers and other equipment. But, even water-based materials can stain; after all, that is what they are for! So it is a good idea to wear an old shirt or an apron.

Acrylic paints, although soluble in water while still wet, become waterproof when dry. If the paint on your brushes dries out, they dry waterproof, too! So your brushes and equipment must be washed immediately.

Cover your table with pieces of newspaper, plastic cloth, or plastic sheeting taped down. It is a good idea to cover the floor, too, especially if there is a carpet.

Make sure you clean all your equipment afterward and clean up. Keep your work safe and clean, too.

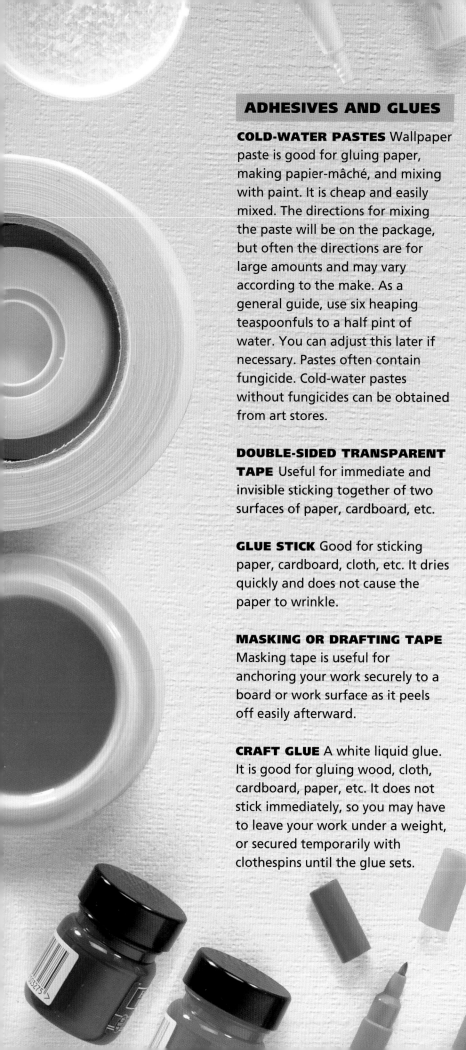

## ADHESIVES AND GLUES

**COLD-WATER PASTES** Wallpaper paste is good for gluing paper, making papier-mâché, and mixing with paint. It is cheap and easily mixed. The directions for mixing the paste will be on the package, but often the directions are for large amounts and may vary according to the make. As a general guide, use six heaping teaspoonfuls to a half pint of water. You can adjust this later if necessary. Pastes often contain fungicide. Cold-water pastes without fungicides can be obtained from art stores.

**DOUBLE-SIDED TRANSPARENT TAPE** Useful for immediate and invisible sticking together of two surfaces of paper, cardboard, etc.

**GLUE STICK** Good for sticking paper, cardboard, cloth, etc. It dries quickly and does not cause the paper to wrinkle.

**MASKING OR DRAFTING TAPE** Masking tape is useful for anchoring your work securely to a board or work surface as it peels off easily afterward.

**CRAFT GLUE** A white liquid glue. It is good for gluing wood, cloth, cardboard, paper, etc. It does not stick immediately, so you may have to leave your work under a weight, or secured temporarily with clothespins until the glue sets.

**TRANSPARENT TAPE** Useful for immediate joining of cardboard, paper, etc. when the seams will not be in view.

## DYES

**COLD-WATER DYE** These are simple to use and are obtainable from hardware and department stores. They need water from the hot faucet and salt to mix with the setting ingredient.

**FABRIC PAINT** A variety of brands are available. The paints are usually packed in small jars. Simple to use, the colors are normally set by <u>ironing with a hot iron</u>. These directions may vary with different brands.

**FABRIC PENS** These are very similar to ordinary felt-tipped pens, but the colors can be set by <u>ironing with a hot iron</u>. These directions may vary with different kinds.

## EQUIPMENT

**BENCH HOOK** Used in linocutting. One end hooks over the worktable edge, the other provides a surface to push the linoleum against and prevent it from slipping. It allows you to keep your fingers out of the way of the cutters. It is very simply made from scraps of wood.

| | |
|---|---|
| A piece of wood or chipboard | 6 x 9 x ¾ inches |
| Two pieces of wood | 6 x 1 x 1 inches |
| Four wood screws | 1¼ or 1½ inch |

Simply screw the pieces of the 1-inch-square wood to the front

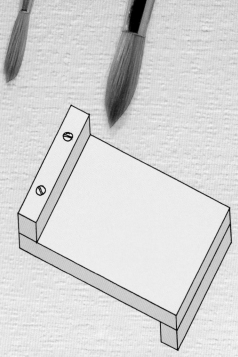

and back of the larger piece of wood, but at opposite ends. This will make a Z-shape when seen from the side. See illustration above.

**BRUSHES** Both bristle and soft hair brushes are useful and available in a variety of sizes and shapes. A medium-sized bristle brush, flat or round shape, is ideal for general use. Change to a different size when you need to; a large brush if you have a large area to cover, a small brush if there are small shapes and detail to paint.

Cheap soft brushes can be too floppy and blunt-ended, and will be irritating and hard to use. Sable brushes are best, but are extremely expensive. There are, however, many soft brushes made with synthetic fibers at more reasonable prices. Stenciling brushes are made from bristles put together to make a flat-ended, round shaped brush. They are available in different sizes.

Keep all your brushes clean. Be especially careful when using acrylic paints. Never leave brushes standing in a jar of water, as this will bend the hair.

**CRAFT KNIFE** There are many designs of craft knife available. If you need to use one, look for its safety qualities. Get one with a retractable blade. Make sure the knife is not thin and flexible. Always keep the knife closed when it is not in use, and in a safe place. <u>Keep your fingers out of the way when you are cutting</u>. You will need a surface to cut on, a piece of hardboard for instance, to prevent cuts on your table or floor. Special cutting mats and boards are available.

**INKING PLATE** This is the name given to a flat sheet of plastic, thick glass, or metal that is used for rolling printing ink on.

**LINOLEUM** The linoleum used in linocuts is of a particular kind. It can be bought from art and craft stores already cut into small rectangles. A thick vinyl is also available as an alternative.

**LINOLEUM CUTTERS** A set of different shaped cutters, together with a handle, comes in a box, usually with instructions for use. They are available from art and craft stores. They are sharp and should be used with care.

**PAINT ROLLERS AND SPONGES** Use them with ready-mixed paints, particularly for large-scale work. They can be used for simple printing with paint.

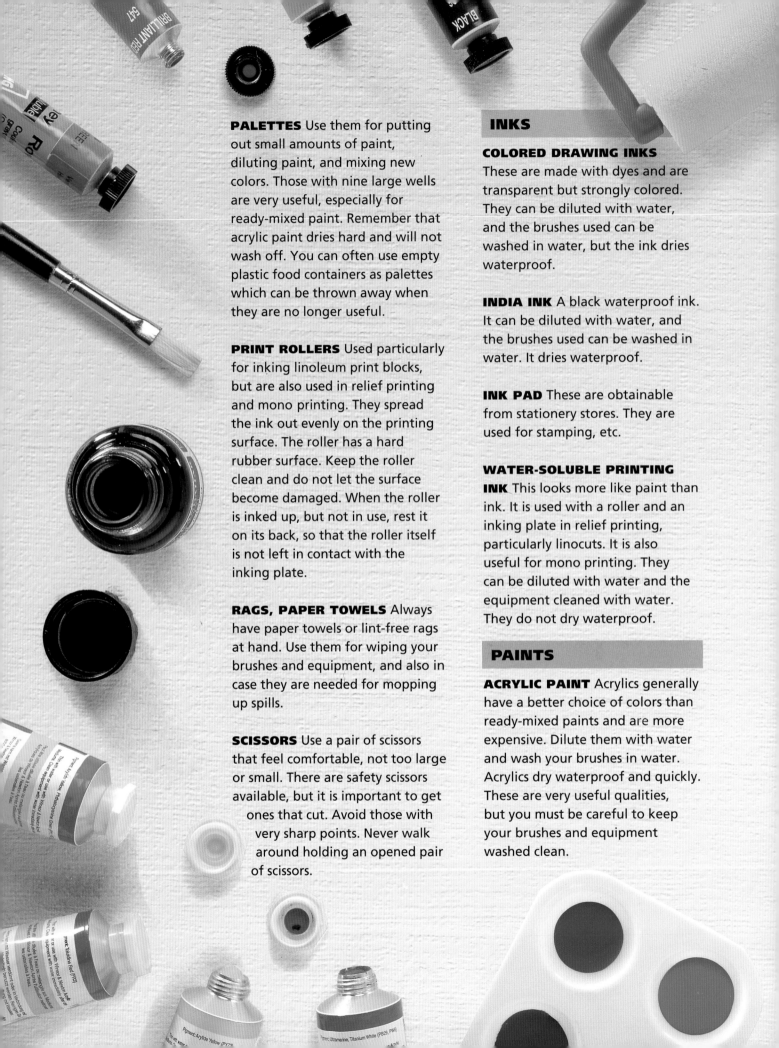

**PALETTES** Use them for putting out small amounts of paint, diluting paint, and mixing new colors. Those with nine large wells are very useful, especially for ready-mixed paint. Remember that acrylic paint dries hard and will not wash off. You can often use empty plastic food containers as palettes which can be thrown away when they are no longer useful.

**PRINT ROLLERS** Used particularly for inking linoleum print blocks, but are also used in relief printing and mono printing. They spread the ink out evenly on the printing surface. The roller has a hard rubber surface. Keep the roller clean and do not let the surface become damaged. When the roller is inked up, but not in use, rest it on its back, so that the roller itself is not left in contact with the inking plate.

**RAGS, PAPER TOWELS** Always have paper towels or lint-free rags at hand. Use them for wiping your brushes and equipment, and also in case they are needed for mopping up spills.

**SCISSORS** Use a pair of scissors that feel comfortable, not too large or small. There are safety scissors available, but it is important to get ones that cut. Avoid those with very sharp points. Never walk around holding an opened pair of scissors.

## INKS

**COLORED DRAWING INKS** These are made with dyes and are transparent but strongly colored. They can be diluted with water, and the brushes used can be washed in water, but the ink dries waterproof.

**INDIA INK** A black waterproof ink. It can be diluted with water, and the brushes used can be washed in water. It dries waterproof.

**INK PAD** These are obtainable from stationery stores. They are used for stamping, etc.

**WATER-SOLUBLE PRINTING INK** This looks more like paint than ink. It is used with a roller and an inking plate in relief printing, particularly linocuts. It is also useful for mono printing. They can be diluted with water and the equipment cleaned with water. They do not dry waterproof.

## PAINTS

**ACRYLIC PAINT** Acrylics generally have a better choice of colors than ready-mixed paints and are more expensive. Dilute them with water and wash your brushes in water. Acrylics dry waterproof and quickly. These are very useful qualities, but you must be careful to keep your brushes and equipment washed clean.

**READY-MIXED PAINT** Brightly colored and water-soluble, these paints are cheap and easily available. They are useful for painting on paper, cardboard, etc.

**SILK VINYL PAINT** A paint made for interior decorating. It is very similar in character to acrylic. White silk vinyl can be used for printing nonmetal surfaces. It dilutes in water, and brushes and equipment are washed in water. It dries waterproof.

## PAPER AND CARDBOARD

**CARDBOARD** Available in a great variety of thicknesses, colors, and finishes. Thin cardboard is most suitable for constructing boxes, printing greeting cards, and making frames or mats for your pictures. Cardboard from cereal boxes, etc., is very useful. Use it for making combs and spreaders for use with paint. Glue materials to it when making relief printing blocks, and use it for making templates.

**CARTRIDGE PAPER** A general-purpose white paper for drawing and painting. It is available in different-sized sheets or pads and in different weights. The heavier weight indicates a thicker paper.

**LINING PAPER** Produced for lining walls prior to painting or wallpapering. It is sold in rolls, is cheap, and is particularly useful if you need a good length of paper, for a frieze, for instance.

**NEWSPRINT** Newsprint is available from art and craft stores by the sheet. Many cheap drawing pads are made with it. However, it is useful for large-scale work if you can get the end of a roll from a newspaper office or wastepaper merchant. They usually make a small charge for it.

**CONSTRUCTION PAPER** A thin but strong paper, it is available in intense, bright colors from stationery stores and art and craft stores. Useful for printing on and using as wrapping.

## VARNISH

**INTERIOR QUICK-DRYING VARNISH** Used for giving a final gloss or satin coat to craftwork. It dries in thirty minutes, is low odor, and brushes are cleaned simply in water.

## WAX CRAYONS

**WAX CRAYONS** Sold in sets of bright colors. The thick ones are the easiest to handle and less likely to break. They are available in long and short sizes.

## TECHNIQUES

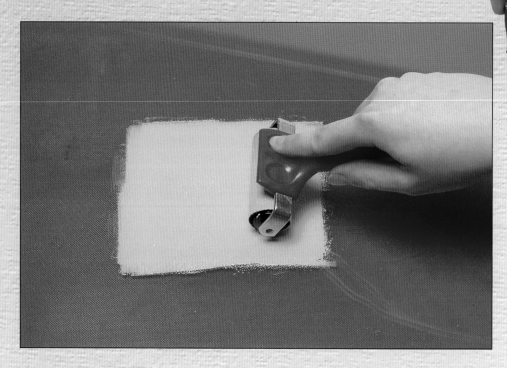

### RELIEF PRINTING

This term applies to all the printing processes where ink is applied to the top surface of a printing block and then printed onto paper. The printing block may be made from many things. Traditionally, it was wood or metal, but it can also be made from linoleum or thick cardboard. You can also print directly from objects by rolling printing ink or paint over them and pressing onto paper.

### INKING UP

For relief printing with a roller and printing ink, you need to roll some ink on an inking plate first. Squeeze out an inch or so of ink onto the plate. You can spread it out with a plastic knife if you have one. Use your roller to distribute the ink evenly over the inking plate by rolling back and forth. Try to keep the ink in a rectangle and not spread all over the plate. Roll in

one direction and then at right angles to it, until you have no lumps or holes in the ink surface.

Listen to the sound of the roller on the ink. If it is making a loud, tearing kind of sound, it is too thick. You should spread it out a bit more, until it makes more of a hissing sound when you roll it. If the ink itself is too thick, or the plate is drying up, the ink can be diluted with a little water.

When the roller is inked, you then transfer it to your block and roll over the surface several times in each direction until the ink is evenly distributed over the surface.

### MONO PRINTING

This term applies to those printing processes where the print is more or less unique. The simplest way is perhaps to paint directly onto a flat surface, such as an inking plate. Then place a sheet of paper over it and press down. You will produce

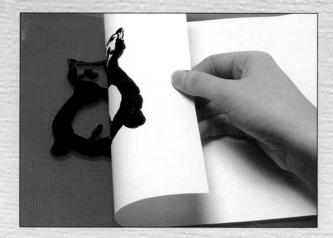

"Love Letters," make sure that you complete "A Basic Linocut Print" project on page 88, so that you learn the techniques properly.

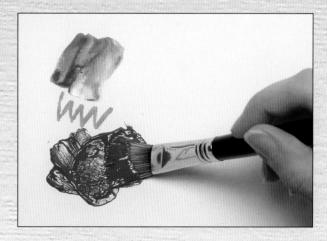

a mirror-image print of your painting. The process imparts interesting textural and chance qualities of its own.

## LINO PRINTING

A lino print is a relief print. You make your own printing block by cutting the design into a piece of linoleum with special cutting tools. It is very similar to the much older craft of woodcut printing. You can print a virtually unlimited number of identical prints. The simplest method of making a print is to use one color. Multicolored prints can be made by cutting and printing at different stages, or by using more than one block. Before you try to make the "Cut-out Clown" or the

## PAINTING

Painting is the most direct and expressive way to apply color. There are a number of different kinds of paint that can be mixed with water, and they each have their own qualities of handling. They can all be thinned down to a transparent quality with water, and to a certain extent, all can be used opaquely, too. Acrylic paint can be used very thickly, but ready-mixed paint (and gouache or poster paint) will crack and come away if used too thickly. Those paints called watercolors are designed to be used transparently.

Glue such as craft glue or wallpaper paste, which has been mixed with water, can be added to ready-mixed paint to give it more texture.

All these paints will work on most absorbent surfaces such as wood, cardboard, paper, or cloth. On shiny or plastic surfaces it is useful sometimes to add dish washing detergent to your paint to help it spread and adhere.

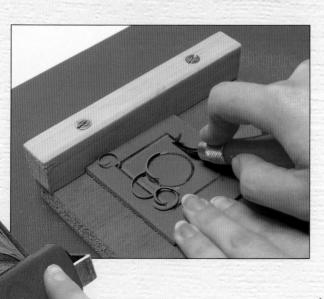

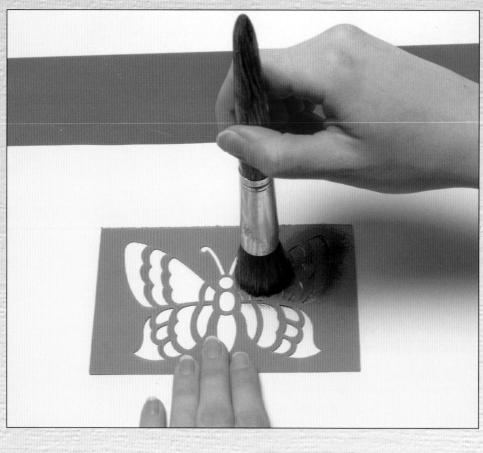

### STENCILING

Stenciling is a particular way of painting that allows you to produce an unlimited amount of identical images. Using a stencil brush, you dab color through holes cut in thin cardboard or plastic. Hold the brush upright to achieve the best results, and lift the stencil off carefully. There are many different stencils available in art and craft stores; patterns, animals, flowers, people, etc. They are very useful as a way of decorating all kinds of surfaces; wooden boxes, walls, and furniture as well as paper. You can also combine them to make pictures. It is sometimes necessary to hold a stencil in place with masking tape. You can buy stencil paper and cut your own designed stencil, or use "found" or ready-made objects, such as paper doilies, as stencils.

### MIXING COLORS

All the paints used in *Krafts for Kids: Paint* can be mixed to make new colors.

Red plus yellow makes orange
Red plus blue makes purple
Blue plus yellow makes green

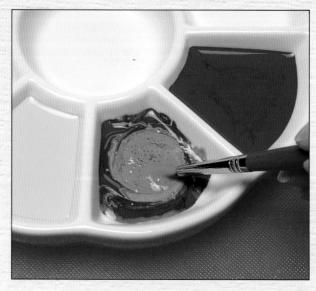

Red, blue, and yellow are called primary colors. Green, purple, and orange are called secondary colors. You may find that your mixing does not make the expected result. For instance, if you want to make purple, you need red and blue. If the red you use is an orange sort of red, you will get a brownish color because you are adding yellow to the mixture. You can experiment and see just how many different colors are possible by mixing the colors you have.

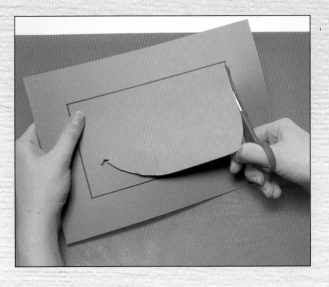

## MAKING A FRAME

It often helps to display your work by mounting it in a cardboard frame. Cut a "window" in a piece of cardboard, allowing a couple of inches all around as a border. Remember to cut the hole in the cardboard smaller than your picture. If your picture comes right up to the edge of the paper it is on, you can only overlap the frame by a quarter-inch or so. If there is a lot of space around your picture, you can cut a smaller hole, bringing the frame edge closer into your picture.

Decide how big your window is going to be and measure it carefully on the cardboard. With thin cardboard you can cut the hole out with scissors. Hold the picture in place behind the hole with tape.

## SCORING

When you are making things from paper or cardboard, you will often need to make folds. To make a neat fold, it is useful to score along the fold line first. Run the back edge of a pair of scissors along the line of the fold, thus making an impression along the line. Make sure to do it on what will be the inside of the fold. You may find another implement that works well; a letter opener or a plastic modeling tool, perhaps.

# Think Ink

Try these three ways of playing with color.
See what effects and forms you can create with ink.

**YOU WILL NEED**

- Masking tape
- Board or newspaper
- Sponge roller
- Large plastic tray
- Water
- Eye droppers
- Colored inks (blue, purple, yellow, red)
- Containers for inks
- Drinking straws
- Plain white paper towels
- Paper

**Experiment 1**

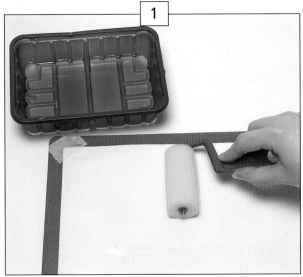

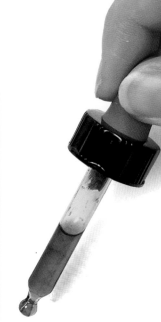

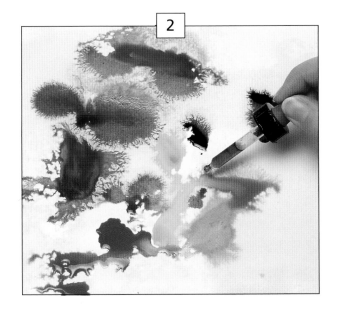

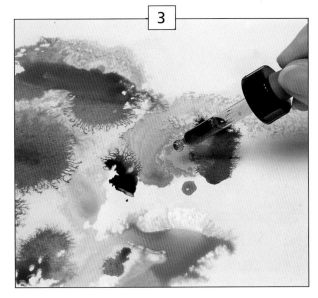

1 Tape your paper onto a board or newspaper with masking tape. Dampen the paper using the sponge roller.

2 Use the eye dropper to drop a few drops of colored ink onto the damp paper. Watch the way it spreads.

3 Clean the dropper if you only have one. (Some colored inks have droppers already in their lids.) Drop another color onto the paper. Watch how the colors blend. Try dropping on some spots of water, too.

## Experiment 2

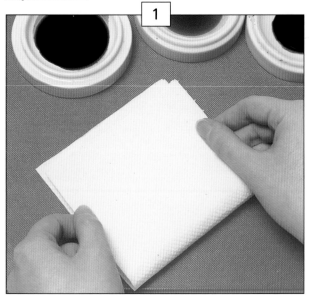

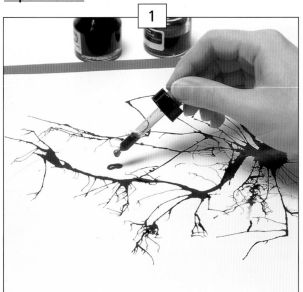

1 Take a sheet of dry paper. Drop some ink on it.

2 Blow the ink through your straw. You can chase it across the paper. See how it splits like a tree's branches. Try some more colors. Turn the paper around. Wave the straw around while you are blowing.

## Experiment 3

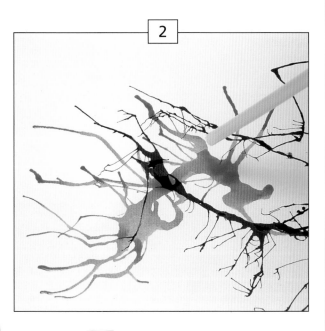

1 Put a few drops of colored ink into separate containers. Dilute them with a little water. Take a white paper towel and fold it into eight.

2 Dip a corner into one of the colors. Then dip another corner into a different colored ink. Continue with the other corners.

3 Unfold and let it dry.

### TIP

☞ Now try folding the paper in different ways – diagonally perhaps – and dipping it differently.

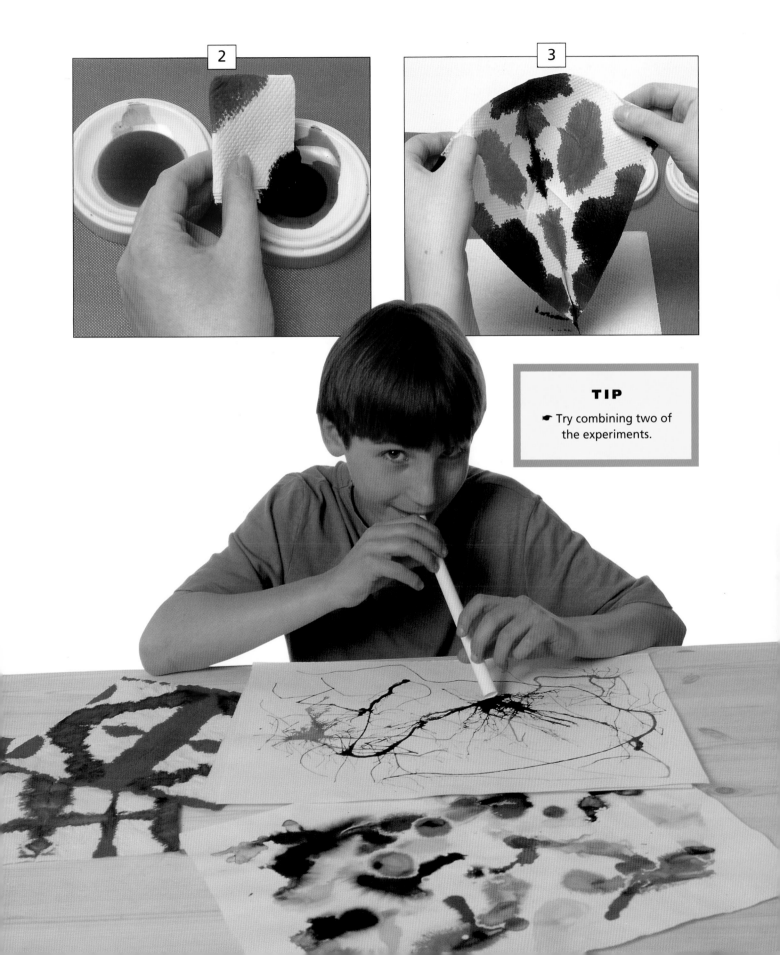

**TIP**
☛ Try combining two of the experiments.

# Wax and Wash

Wax naturally resists water and so provides the process
for this visually dramatic technique.

## YOU WILL NEED

- Wax crayons
- Paper
- Palette
- Ready-mixed paint (black)
- Water
- Paintbrushes
- Plain white candle (optional)

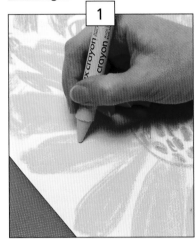

**Painting 1**

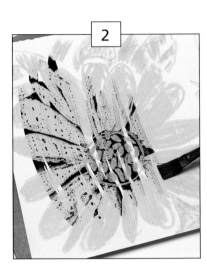

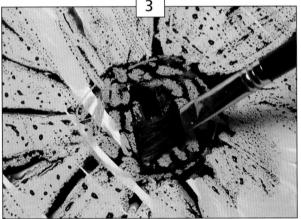

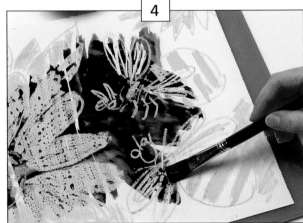

1 Draw firmly on your paper with the wax crayons.

2 Thin a dark-colored paint with some water. Now brush a wash of the paint over your wax-crayon drawing.

3 The wax resists the water paint and shows through.

4 Put the paint on lightly, without rubbing it too hard.

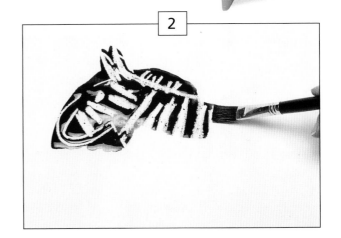

## Painting 2

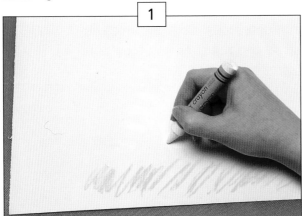

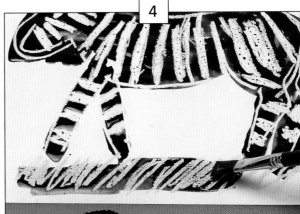

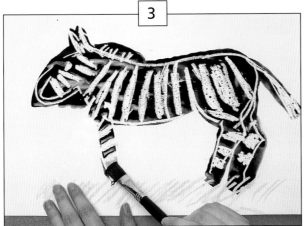

1 Try drawing with a candle or white wax crayon. It is hard to see what you have drawn, but if you tilt the paper toward the light, you can just see it.

2 Paint over the drawing with black paint. Your picture will begin to appear.

3 Paint only where you have drawn with the crayon.

4 When you have painted over all the white crayon, your picture will be revealed.

# Wash Away

When you put your painting under running water, watch your picture gradually appear. The unexpected qualities and textures that result are always a surprise and visually exciting.

## YOU WILL NEED

- Ready-mixed paint (not acrylic) (white)
- Containers for paint
- Paintbrushes
- Cartridge paper
- India ink or waterproof black ink

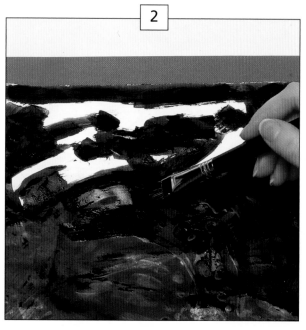

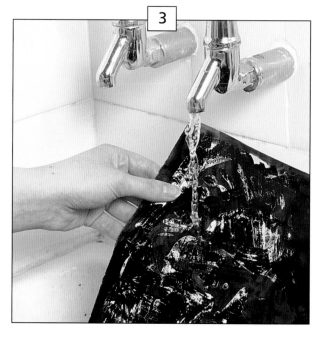

1 Using the white paint, paint all the parts of your picture that you want to remain white. Make sure the paint is fairly thick. Leave gaps where you want black lines.

2 When your painting is dry, paint over the whole paper with black ink.

3 When the ink is dry, hold your painting under cold running water. The ink will wash away where the white paint was and leave that paper exposed.

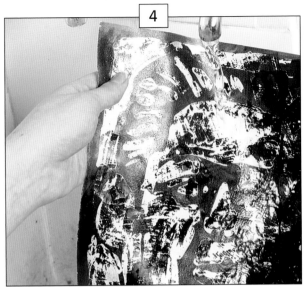

4 You may need to rub gently with your fingertips to remove all the ink from the painted areas, but take care not to rip the paper. Leave it to dry.

**TIP**
☞ Try the process with a different-colored waterproof ink.

# Paint a Pot

Brighten up your windowsill by transforming your flowerpots
with these colorful designs.

## YOU WILL NEED

- Terracotta flowerpots
- Acrylic paints (black, white, orange, red)
- Paintbrushes
- Water
- Pencil

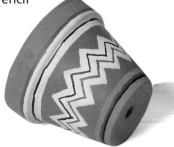

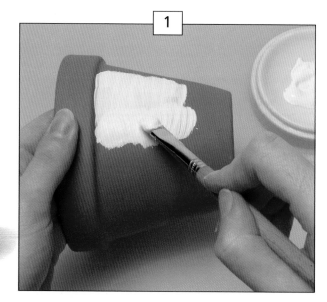

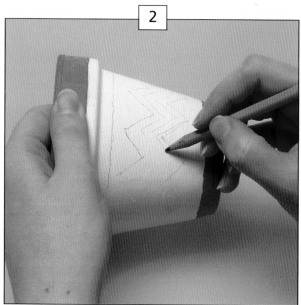

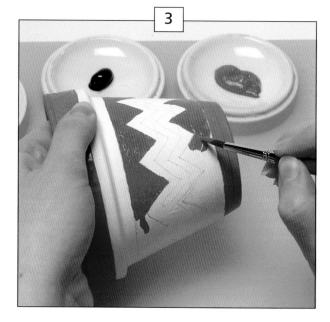

1 Make sure the flowerpots are clean. You may have to scrub them if they are old. Give the pot a coat of white paint first where you want to paint your patterns. Hold the pot sideways by the rim. Turn the pot as you go. Allow the paint to dry.

2 You can draw your chosen design on with a pencil if you want to.

3 Use strong bright colors. Keep the paint thick. Paint patterns around the pot.

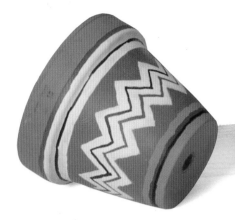

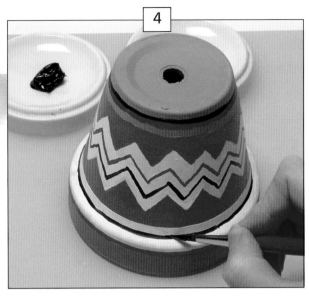

4 Let the paint dry before painting another color on top of it. You can add diagonal stripes, dots, or crosses, for example. Leave the black stripes until last.

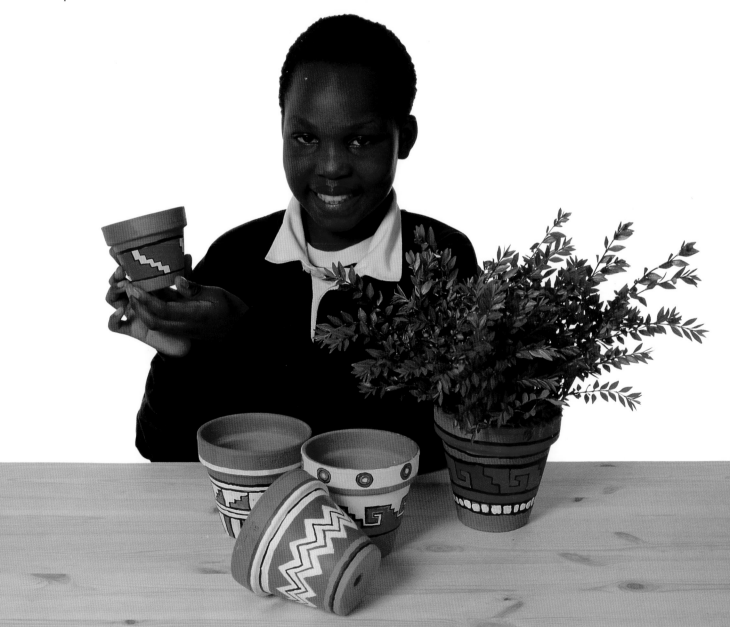

# Play and Paint

Get together with your friends and work on a painting big enough for you all to have a turn . . . where anything goes.

## YOU WILL NEED

- Ready-mixed paint (green, red, black, brown, blue, yellow)
- Flat trays for paint
- Water
- Sponge rollers/sponges
  A large sheet of paper (perhaps you can tape sheets of newsprint or lining paper together)

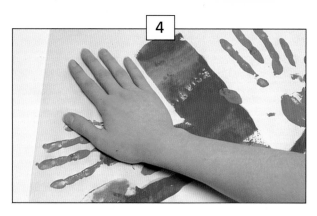

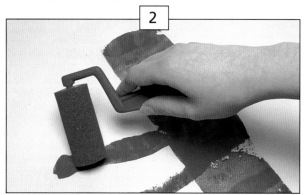

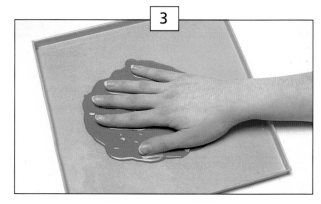

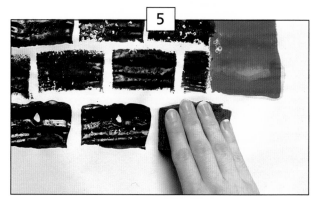

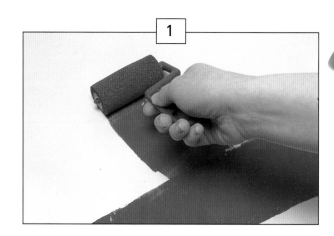

1 Three basic shapes are used in this painting. Put some paint in a tray and dilute with a little water. Use the sponge rollers to draw tree trunks, branches, and landscape.

2 You can use the edge of the roller for thinner lines.

3 Spread out some green paint in a large, flat tray. Put one of your hands into the paint.

4 Spread out your fingers and print leaves on the trees.

5 Use sponges to print bricks for the buildings.

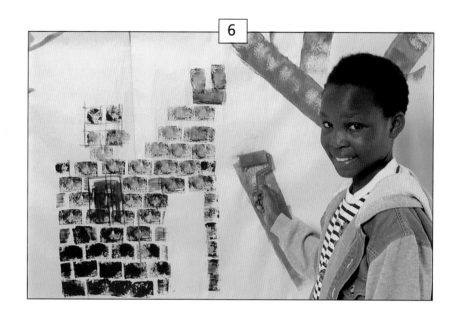

**TIP**

☛ Tape the paper to a wall if you can. Put some newspaper along the bottom to catch any drips. On a nice day you can work outside in the yard or in the garage.

6 With your friends, work together to paint the picture.

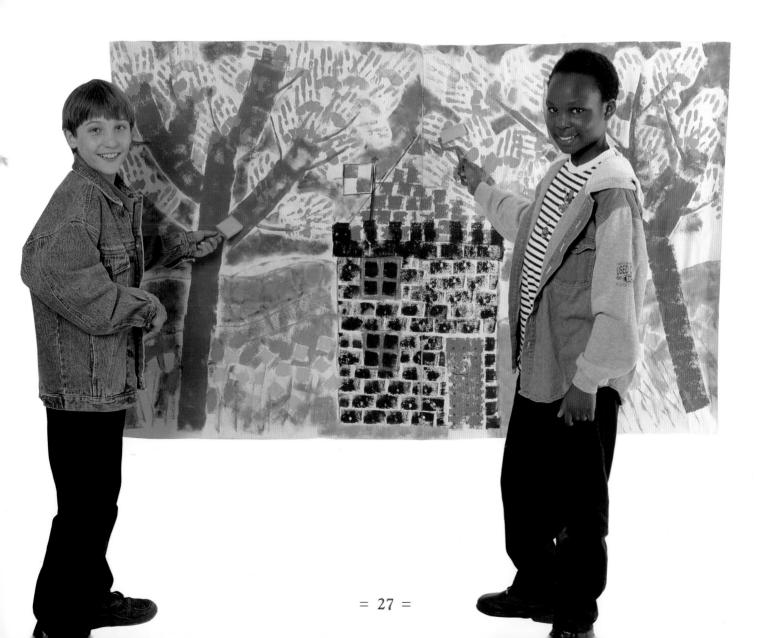

# Petal Paperweight

First catch your stone! This project shows you how to make a paperweight. However, if you find a large stone, you can make it into a doorstop in exactly the same way!

## YOU WILL NEED

- Your chosen stone
- Acrylic or ready-mixed paints (white, blue, yellow, orange, brown)
- Paintbrushes
- Pencil
- Paper
- Scrap of cardboard
- Scissors
- Felt
- Craft glue
- Clear varnish

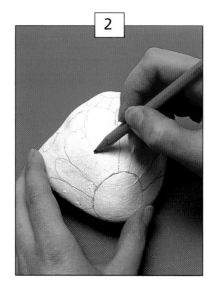

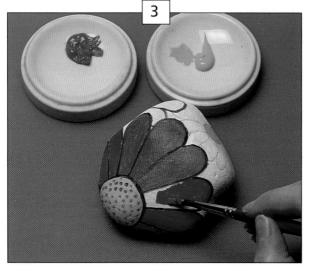

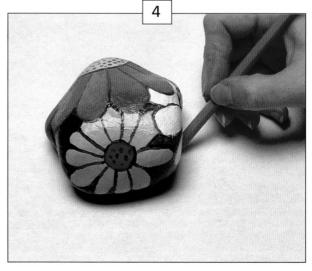

1 Wash your stone well and let it dry. Its shape can give you an idea of what to paint on it. Find which is the best way to stand it. Give the stone a coat of white paint. This will seal the surface and make the colors brighter, especially if you have a dark stone.

2 Draw your design on the stone in pencil.

3 When you are completely satisfied with your design, paint the stone.

4 When you have finished painting the stone, let it dry. Stand it on a piece of paper and draw around it to make a template to fit the base of the stone.

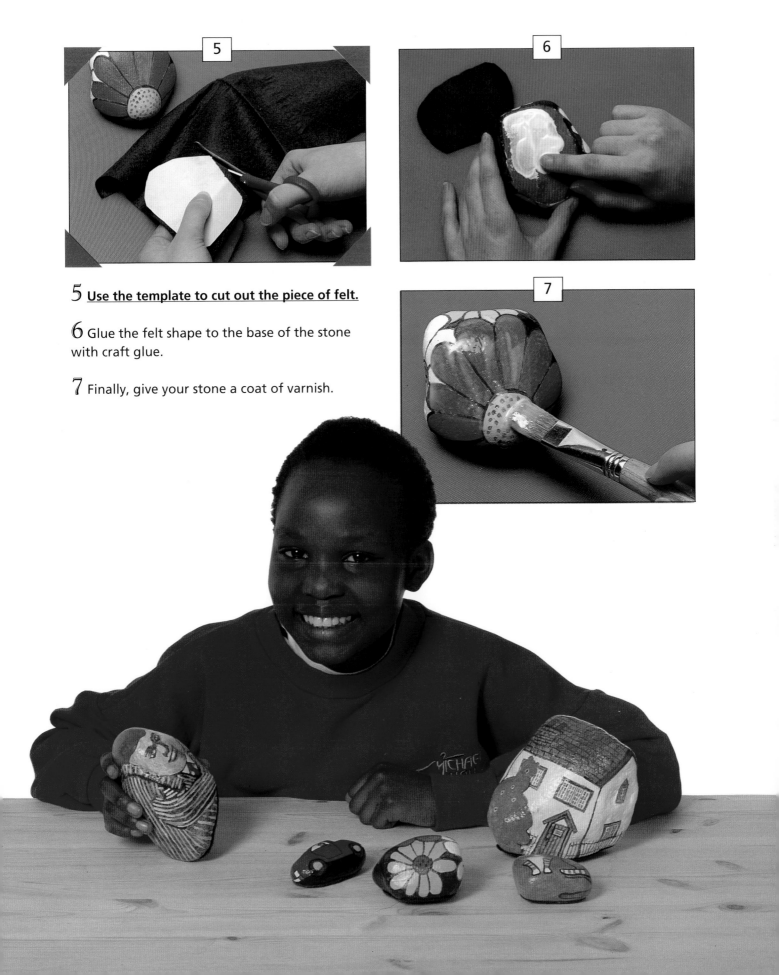

5 **Use the template to cut out the piece of felt.**

6 Glue the felt shape to the base of the stone with craft glue.

7 Finally, give your stone a coat of varnish.

# Bright Light

Make these simple, but attractive candle holders, by recycling jars.

**YOU WILL NEED**

- Glass jars
- Scissors
- Black felt-tipped pen
- Paper
- Soft paintbrushes
- Acrylic paints (yellow, orange, white)
- Shallow containers
- Night lights or short candles

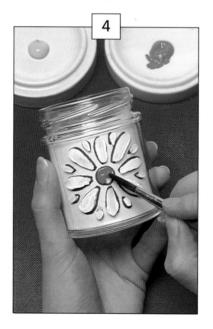

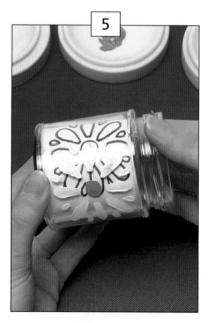

1 You should choose short, wide-mouthed jars. Wash off any labels or glue, and dry. Draw your design with a felt-tipped pen on a strip of paper which will fit inside the jar.

2 Put the design in the jar. Position the drawing where you want the design to be.

3 Try to paint on the glass jar with single brush strokes. Don't let the paint get too watery or it will run.

4 Gradually build up your design using different colors.

5 Slide the paper around in the jar, bringing the next part of your design into its correct position.

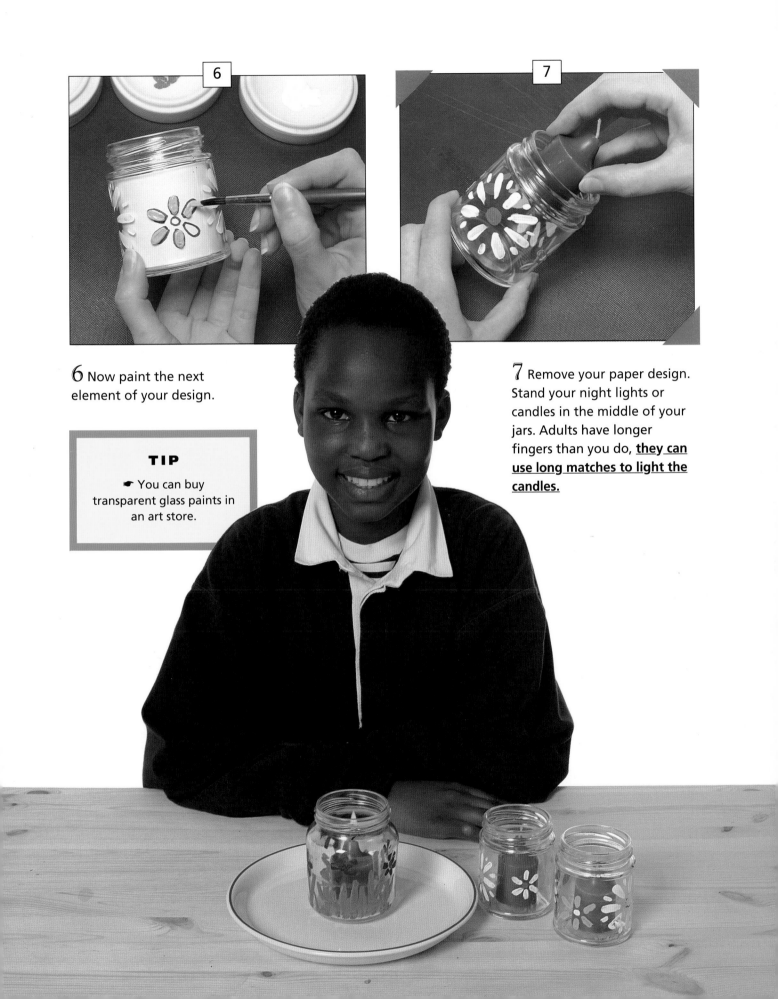

6

7

6 Now paint the next element of your design.

**TIP**

☞ You can buy transparent glass paints in an art store.

7 Remove your paper design. Stand your night lights or candles in the middle of your jars. Adults have longer fingers than you do, **they can use long matches to light the candles.**

# Deep Sea Frieze

Use thick paint and combs to create a frieze of underwater life.

**YOU WILL NEED**

- Wallpaper paste
- Plastic bowl
- Plastic containers
- Ready-mixed paint (orange, green, brown, blue)
- Scissors
- Scrap cardboard
- Paintbrush
- A long sheet of paper (lining paper – or the back of some old wallpaper)

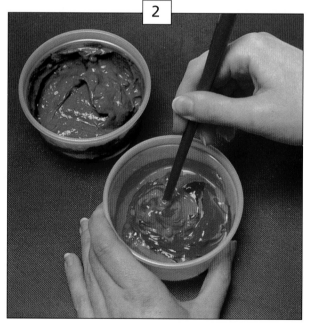

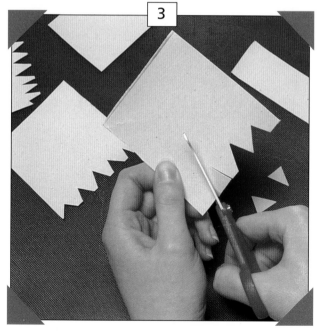

1 Mix some wallpaper paste to a very thick consistency. See page 8.

2 Put some paste into your containers with a different color paint in each and mix.

3 <u>Cut up cardboard to paint with. Cut notches along the edge on some of them to make combs of different sizes.</u>

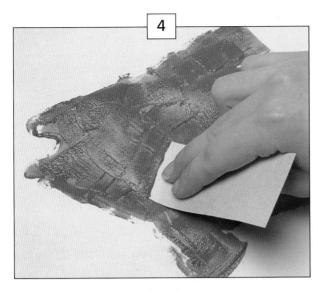

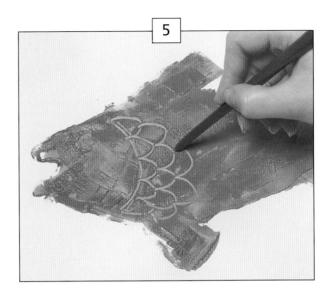

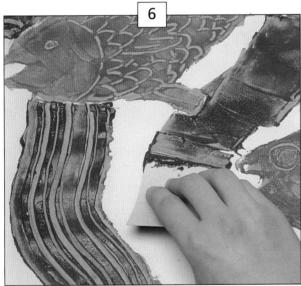

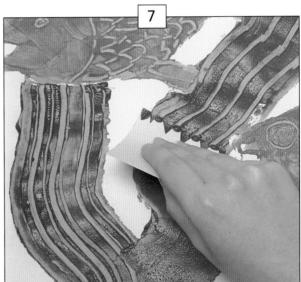

4 Paint the big fish with a flat piece of cardboard.

5 Draw into the paint with the end of a paintbrush handle to make the scales.

6 Now paint the seaweed using flat pieces of cardboard to spread the paint.

7 Scrape through it with the notched combs, so that the paint shows up in lines.

8 Now paint the sea by spreading the paint on with flat cardboard.

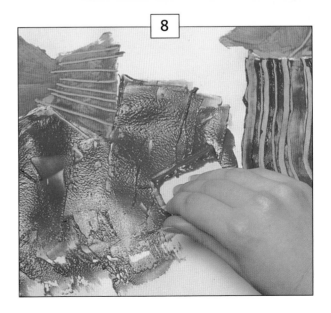

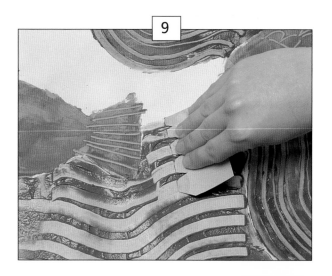

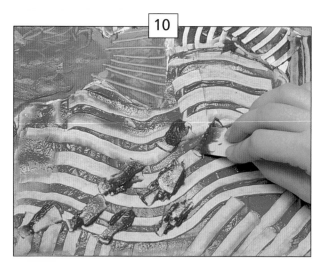

9 Make the water swirl and flow. Make the seaweed wave in the movement.

**TIP**

☛ Join the lengths of your underwater scenes together to form a frieze which you could put around the room.

10 Little fish swim in groups that flow and spiral like water. Put the fishes in using narrow pieces of cardboard.

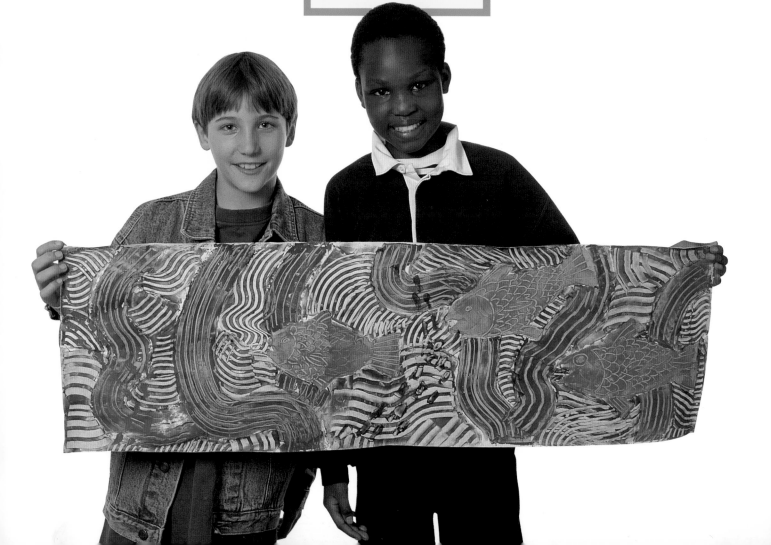

# Stripes and Circles

Change your own boring leggings into these far-out striped ones.

## YOU WILL NEED

- String
- Washed cotton leggings
- Dishwashing bowl
- Water
- Rubber gloves
- Cold-water dye (purple)
- Pitcher
- Salt
- Cold dye fixative
- Wooden spoon or stick
- Laundry detergent

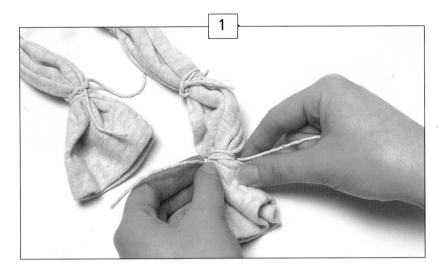

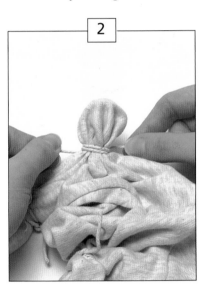

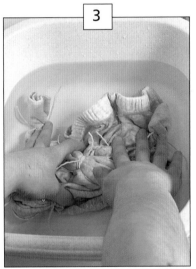

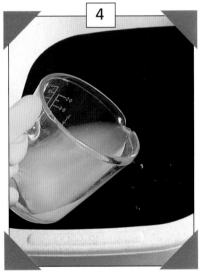

1 Wind the string around one of the legs and tie tightly. Continue tying along both legs, about 2–3 inches apart.

2 As you get near the top of the legs, you can bunch up the cloth and tie around it with the string. These will come out as circles.

3 Fill a dishwashing bowl with water and push the leggings under the water. Make sure they are wet all over. Then remove them and squeeze out any excess water.

4 Fill the bowl again with enough cold water to cover the leggings. **Wear the rubber gloves now and for the next 4 steps. Dissolve the dye in 1 pint hottest tap water in the pitcher. Stir well and add to bowl. Dissolve 4 ounces salt and one sachet of cold dye fixative in about ½ pint hottest tap water and add to bowl.**

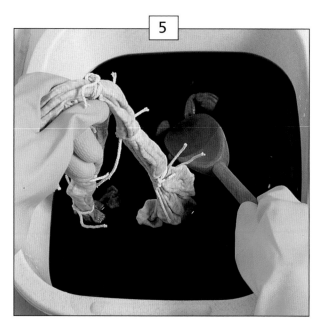

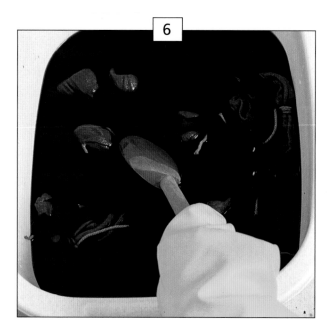

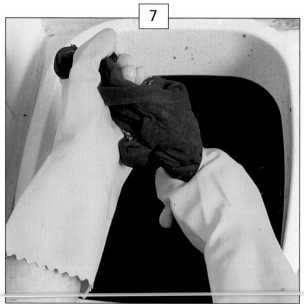

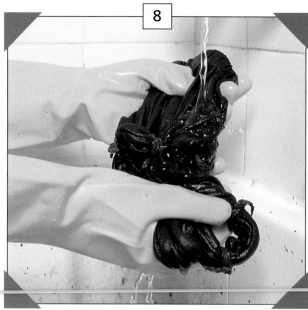

5 Put the damp leggings into the colored dye. Leave in for one hour.

6 Use the wooden spoon/ stick to stir the leggings around for the first ten minutes. After that, stir occasionally. Make sure they stay under water.

7 Remove leggings from the dye – squeeze out excess dye.

8 Rinse under cold water until the water runs clear. **Wash in hot water with your usual washing detergent.**

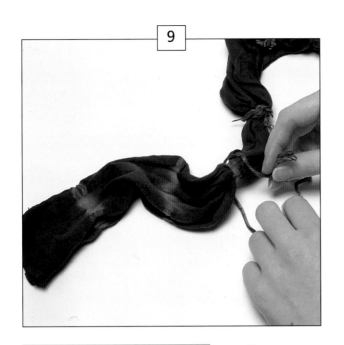

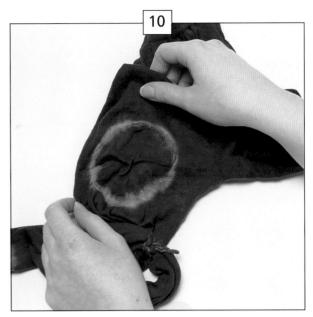

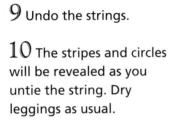

### TIP

☛ You can use this technique on any cotton garment such as a shirt or T-shirt. Lighter colored garments dye best.

9 Undo the strings.

10 The stripes and circles will be revealed as you untie the string. Dry leggings as usual.

# Make Friends

You will need someone else to work with you on this project.
Your companion can be whoever you want.

**YOU WILL NEED**

- Newsprint
- Black felt-tipped pen
- Palette
- Ready-mixed paint
- Paintbrushes
- Scissors
- Craft knife
- Craft glue
- Large cardboard box or sheets of cardboard
- Glue stick
- Pieces of wood

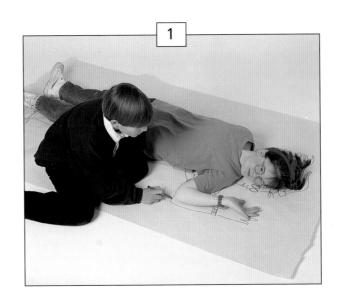

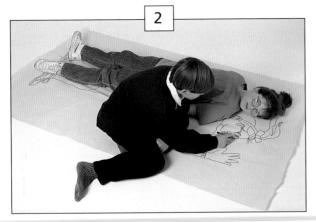

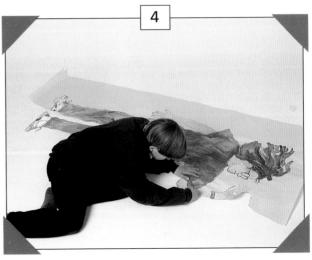

1 Lay the newsprint on the floor. It is best if you lie on a hard surface. Lie down on the newsprint and take a pose. Ask your partner to draw around you with a felt-tipped pen. Keep the pen vertical.

2 Be sure to try to get all the details. Move over to one side, in the same pose, so that your partner can draw in your features, clothes, etc.

3 Paint your figure.

4 **Then cut out your figure.** You could hang it on your bedroom door at this stage.

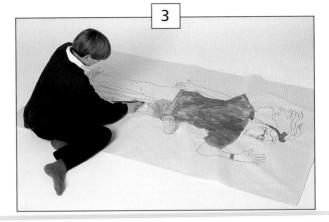

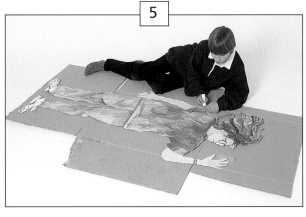

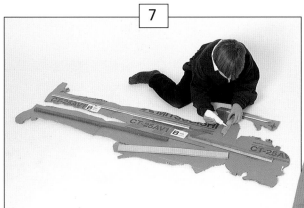

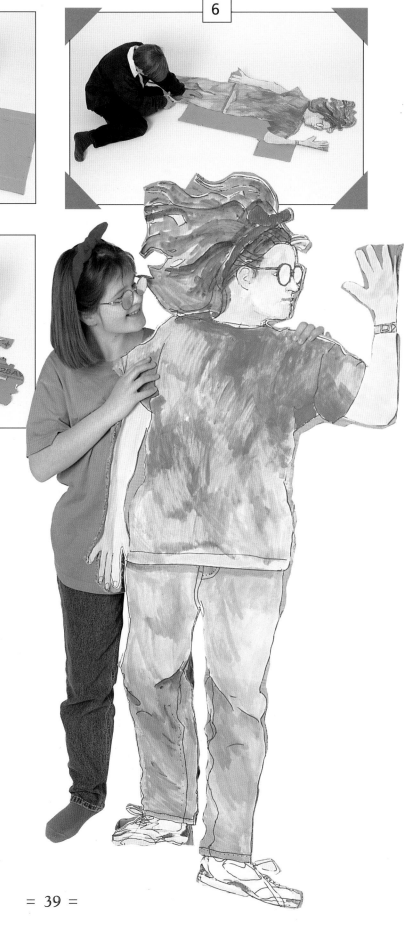

**5** If you want your figure to be sturdier, you could open out a large cardboard box or glue some sheets of cardboard together and glue your painting on it.

**6** **You can then cut your figure out using scissors or a craft knife.**

**7** You may need to glue some sticks on the back to make your figure rigid. Use craft glue for this. Stand your figure up using a bamboo pole or a long stick as a prop.

**TIP**

☛ If your figure is a superhero, it could be flying and suspended from the ceiling.

# Sunflower T-shirt

Turn a plain white T-shirt into this sunny-looking design using fabric paints and pens.

## YOU WILL NEED

- White cotton T-shirt
- Tracing paper
- Pencil
- Scrap cardboard
- Scissors
- Black felt-tipped pen
- Paper
- Fabric color pen (purple, black)
- Thumbtacks
- Board
- Clean cloth
- Iron
- Ironing board
- Fabric paints (green, yellow, orange)
- Paintbrushes

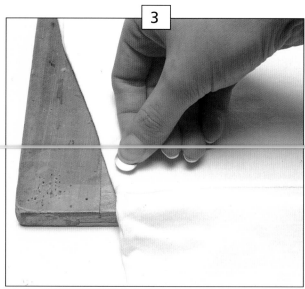

1 If you use a new T-shirt, you must wash it first to get rid of the dressing. If it is not new, you must still make sure it is clean and flat. Trace the templates on page 95. Transfer the tracings to cardboard and **cut them out.**

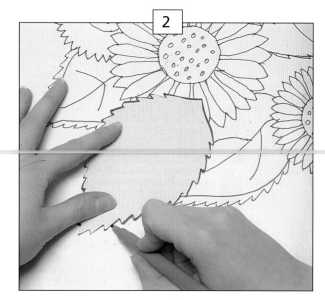

2 You can practice on paper first using an ordinary felt-tipped pen. It is best to draw the complete sunflower first. Then draw the others behind it. Take care when overlapping, and do not draw over the previous flower.

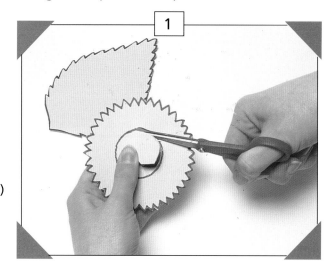

3 Pin the T-shirt onto a board. When you are happy with your design on paper, you are ready to print the T-shirt.

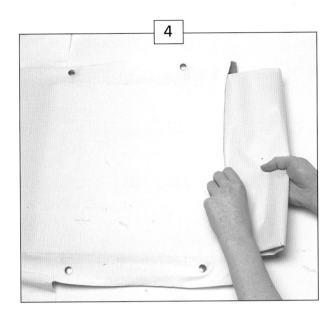

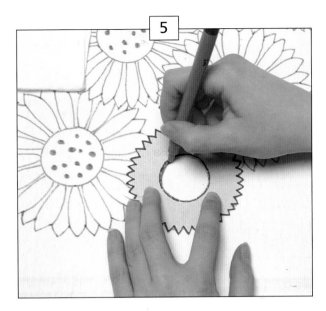

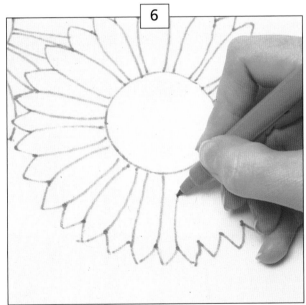

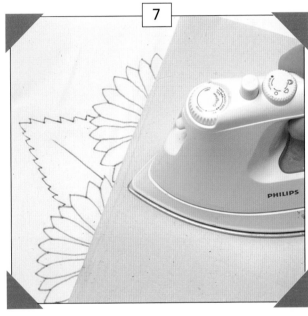

4 Put a sheet of cardboard or layers of paper inside the T-shirt to stop the colors from soaking through.

5 Draw around the flower templates using a fabric pen. Use a different-color pen to draw around the leaf template. Overlap the flowers, and add the leaves.

6 You will need to draw in the lines for the petals for the sunflower. When you have drawn the sunflowers and leaves onto your T-shirt, let the design dry for five minutes.

7 Then cover the T-shirt with a clean cloth. **Ask an adult to help you iron the design for 1–2 minutes on a cotton setting to seal the ink.**

**TIP**

☛ Different paints and pens might have slightly different directions. Follow the instructions on the pack.

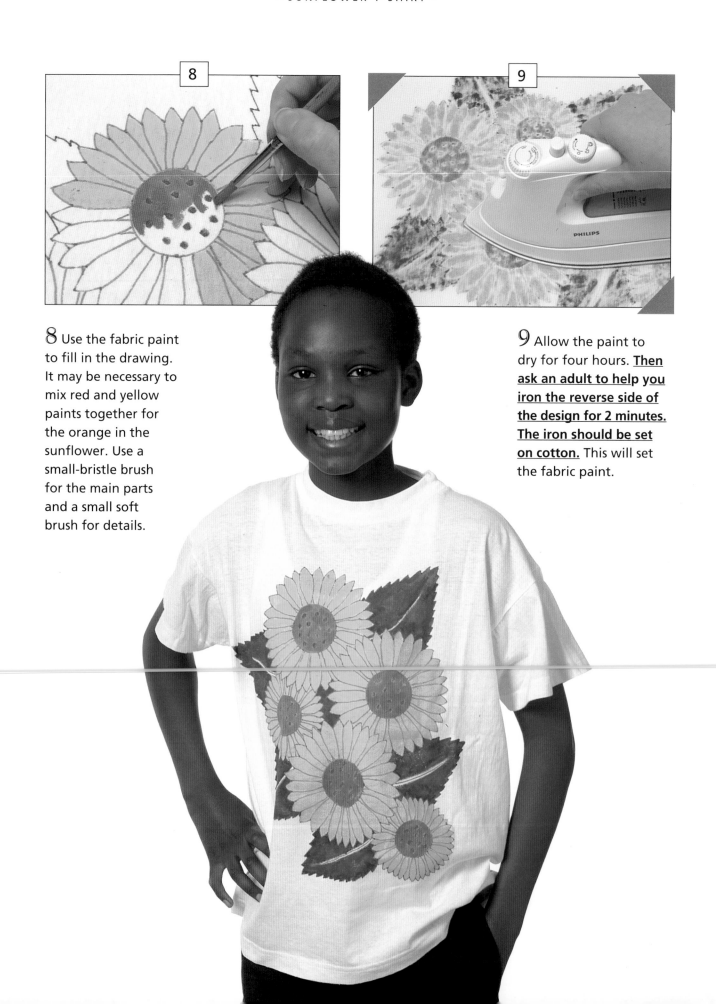

8 Use the fabric paint to fill in the drawing. It may be necessary to mix red and yellow paints together for the orange in the sunflower. Use a small-bristle brush for the main parts and a small soft brush for details.

9 Allow the paint to dry for four hours. **Then ask an adult to help you iron the reverse side of the design for 2 minutes. The iron should be set on cotton.** This will set the fabric paint.

# It's My Party

Use stencils to brighten up paper tableware for a party with your friends.

## YOU WILL NEED

- Acrylic paints (orange, green)
- Water
- Shallow containers
- Stencil brushes
- Stencils
- Paper
- Paper tablecloth and napkins
- White paper plates, cups
- Folded cards
- Envelopes

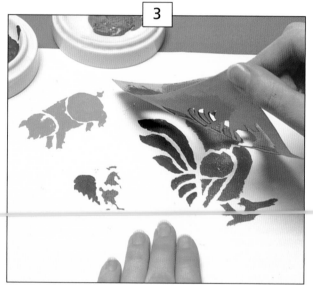

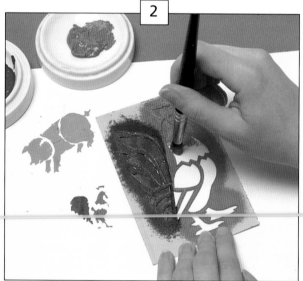

1 Put a little color in a shallow container. First, try stenciling on some paper. Hold your stencil brush vertically and dab it into the paint.

2 Try out a few different stencils first. Hold the stencil down on your paper. Now dab your brush vertically on the stencil until the space is covered. If the paint is too watery or you have too much on your brush, it may run under the edges of the stencil.

3 If you use two colors, allow the first to dry. Take care when you lift the stencil off. Do not drag it.

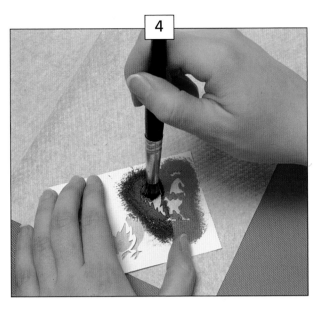

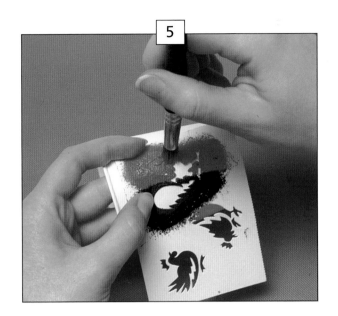

4 When you've got the hang of it, select your stencil. Stencil the napkins and the rest of your objects.

5 When you stencil the cup or anything similar, hold it carefully with one hand, using the thumb and index finger to hold the stencil in place.

**TIP**

☞ Protect your stenciled design and only use your plates for wrapped or dry food.

# Fancy Gift Box

Spray with a toothbrush! – and recycle any box into a gift box.

## YOU WILL NEED

- Colored inks (red, purple)
- Shallow containers
- Eye dropper
- Ivy leaves
- Two old toothbrushes
- Paper
- Pieces of scrap cardboard
- Paper doilies
- Cardboard box
- Glue stick
- Clothespins
- Scissors

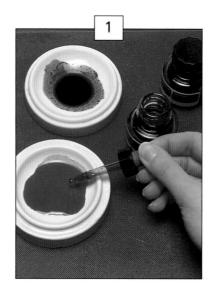

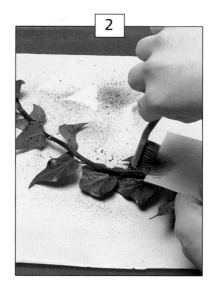

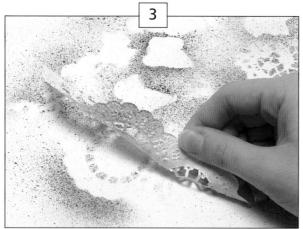

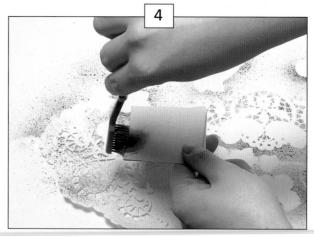

1 Put some different colored inks into shallow containers with an eye dropper.

2 Try out your pattern on some scrap paper first. Lay some ivy across your paper. Dip a toothbrush in one of the inks. Hold the toothbrush over your paper and push it across the edge of a piece of cardboard so that it sprays the ink across the ivy.

3 Now try using a paper doily the same way. Lift it to check what is happening. If there is too much ink on your brush, it will make blobs. It is better to be patient. Experiment until you get it right.

4 Now spray the paper you will use for your box. Use the other toothbrush with the other color ink. Move your ivy and lace across the paper. Change the colors for different parts of your picture. Move the objects and spray again until the paper is covered.

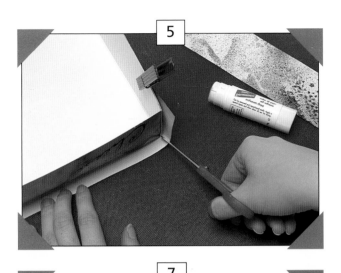

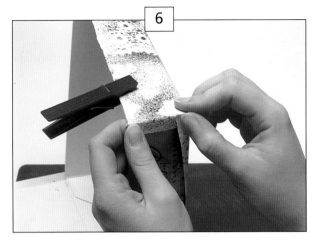

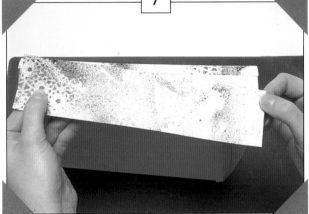

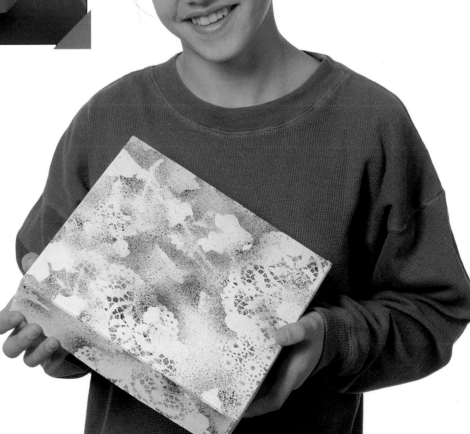

5 Now cover the box lid with the paper. Glue it to the top and over two sides. Cut off the excess paper carefully and put to one side. Hold the paper in place with clothespins while the glue dries. <u>**Snip the corners of the paper where it overlaps the other two sides.**</u>

6 Fold the edges over and glue them down. Hold them together with clothespins while they dry.

7 <u>**Cut the extra paper into strips to cover the remaining two sides.**</u>

# Papier-Mâché Dish

Use waste paper to make this dish with a stenciled decoration.

**YOU WILL NEED**

- Plastic bowl as mold
- Petroleum jelly
- Old newspapers
- Water
- Wallpaper paste
- Plastic mixing bowl
- Teaspoons
- Large paintbrush for paste
- Clean newsprint
- Ready-mixed paint (blue, red)
- Shallow containers
- Stencil brush
- Stencils
- Brush for varnish
- Varnish

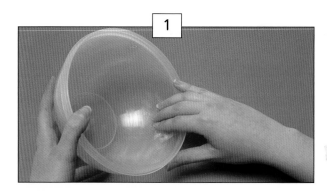

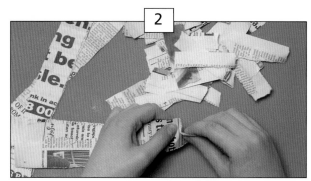

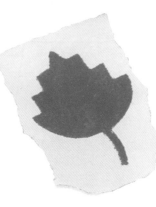

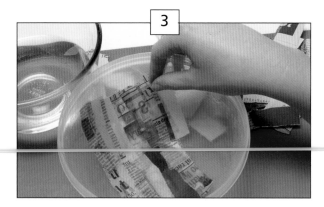

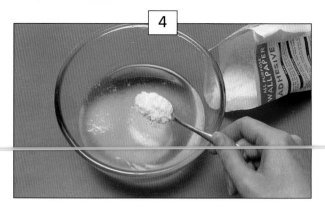

1 Give the inside of the plastic bowl a fine coating of petroleum jelly. This is so that your dish will come away easily when your papier-mâché dish is finished.

2 Tear the newspaper into long thin strips about 1 inch wide. You will find it tears more easily in one direction than the other. Then tear these long strips into 3-inch strips so that you have small pieces of newspaper.

3 Dip the individual strips in water. Shake the excess water off them. Lay them around the inside of the bowl, overlapping them, until it is completely covered.

4 Mix the wallpaper paste in a bowl with water according to directions. See page 8.

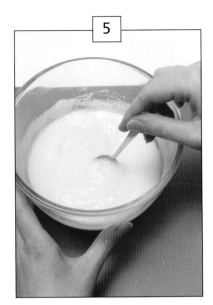

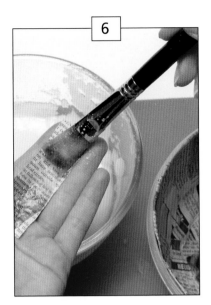

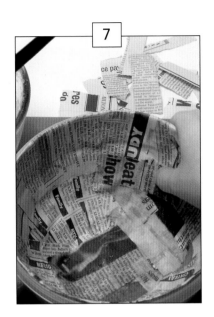

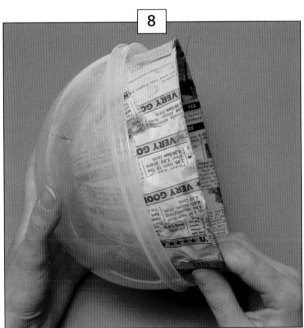

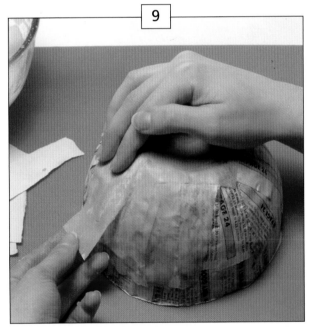

5 Stir well and leave it to form a paste.

6 Paste strips of newspaper with the brush or your hands and lay them around the inside of your bowl.

7 For the second layer, lay the newspaper strips in the opposite direction. Continue layering for four or five layers. Remember to alternate the direction of each layer. Let the paper dry between layers. You can put it on a radiator, or out in the sun, depending on the time of year.

8 When your papier-mâché bowl is dry, take it out of the bowl. To do this, get hold of the edges of the papier-mâché bowl and twist to remove from bowl.

9 Now paste a layer of clean newsprint on your bowl. Tear strips as before and put a single layer on the inside and outside of your bowl.

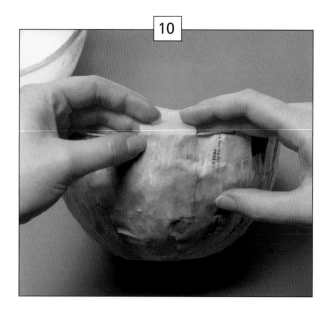

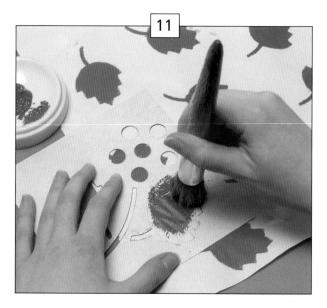

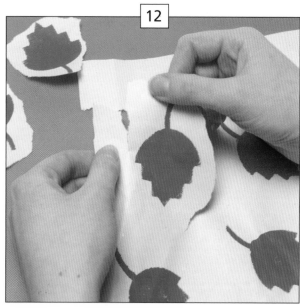

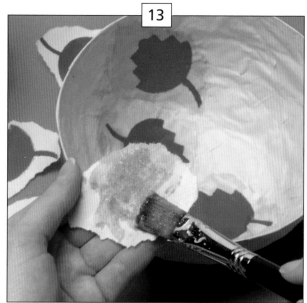

10 Overlap the strips in the same way, but this time take the pieces over the rim of the bowl to make a neat edge.

11 Stencil a number of motifs onto a piece of newsprint and let them dry.

12 Tear these motifs out. Make sure there are torn edges all around the motif and not sharp edges. The torn edges blend in more easily.

13 Paste these motifs onto the inside and the outside of your bowl.

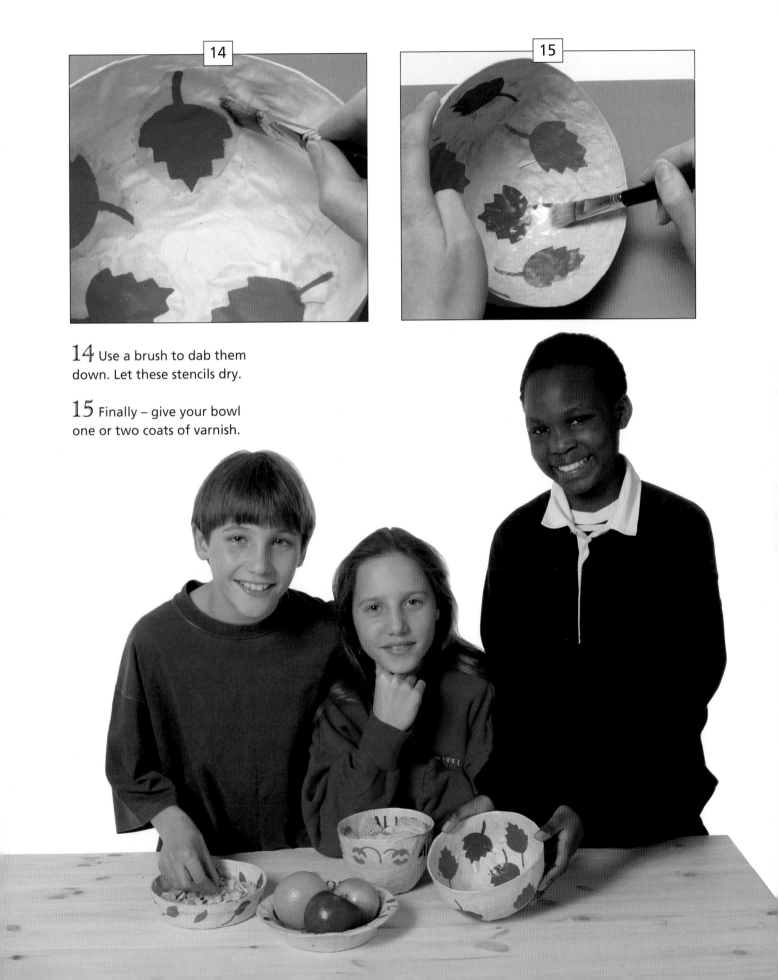

**14** Use a brush to dab them down. Let these stencils dry.

**15** Finally – give your bowl one or two coats of varnish.

# Eggs-ellent!

Wax and inks are used to make these attractive patterned eggs.

## YOU WILL NEED

- Hard-boiled eggs
- Egg cups
- Matches
- Plain white candle
- Waterproof colored inks (yellow, red, blue)
- Paintbrush
- Wire rack
- Baking sheet
- Foil
- Paper towels

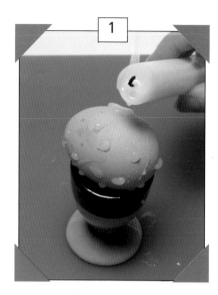

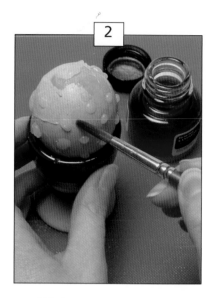

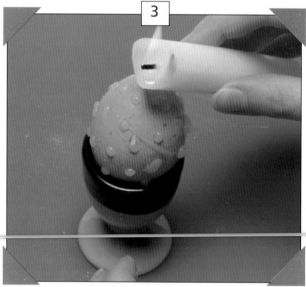

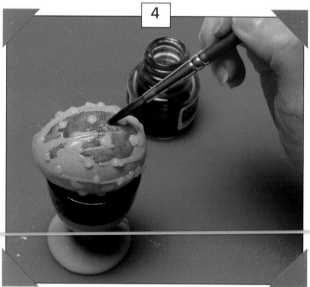

1 Stand a hard-boiled egg in an egg cup. **Ask an adult to light the candle. Let it drip wax on the egg.** The parts covered by the wax will stay that color. You can make spots or stripes or other designs by controlling the wax.

2 When the wax has set, paint the whole egg with yellow ink. Leave it to dry in the egg cup. Turn the egg over and paint the other side, and let that dry.

3 **Now drip some more wax on your egg.** The parts you cover with wax this time will remain yellow.

4 Now paint the egg with red ink. Leave to dry. **Drip more wax onto the egg.** These parts will remain red. Finally give your egg a coat of blue ink.

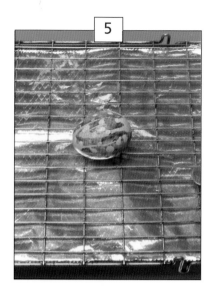

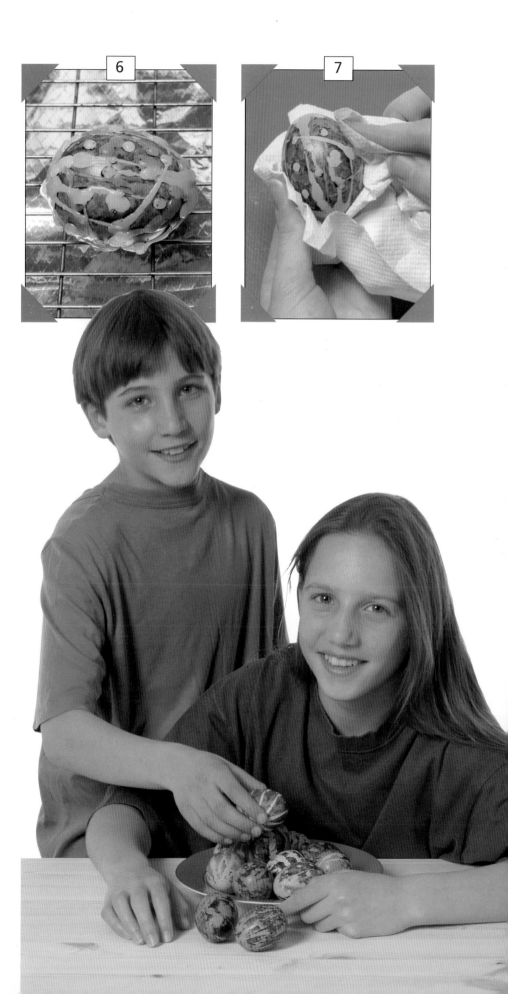

5 When the blue ink is dry, put the egg on a wire rack standing on a baking sheet lined with foil.

6 **Ask an adult to put the sheet in a moderate oven.**

7 This will melt the wax after a couple of minutes. **Ask an adult to remove the sheet from the oven.** Leave the egg to cool for a few moments, **then wipe the wax off with paper towels while holding it in your other hand in a thick wad of paper towels.**

### TIP

☞ This process is known as batik, and you can decorate fabrics this way with a special wax and its applicator.

# CHAPTER THREE

# Relief
# Printing
· · · · · · · · · ·

# Falling Leaves

Explore your neighborhood. Discover and collect a variety of interesting shaped leaves for your print.

## YOU WILL NEED

- Printing inks (blue, green)
- Sheet of glass or plastic (inking plate)
- Printing roller(s)
- Newsprint
- A variety of leaves
- Colored paper
- Cardboard frame
- Scissors
- Craft glue

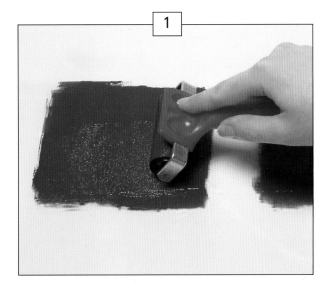

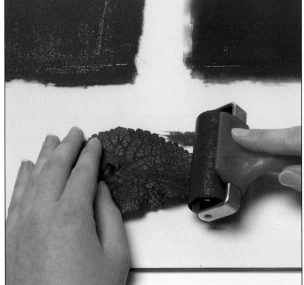

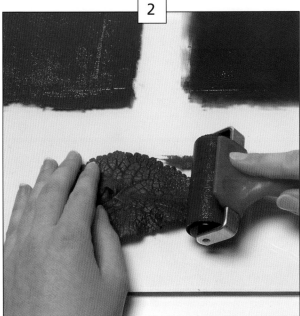

1 Put some ink on your inking plate and ink your roller.

2 Roll over a leaf with the inked roller. Make sure you put enough ink on.

3 Practice on newsprint. Place the leaf ink side down on your paper. Cover it with another piece of paper.

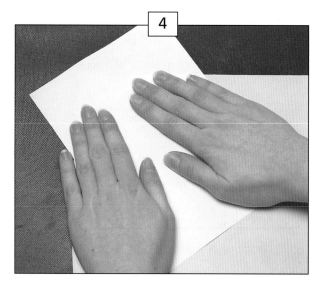

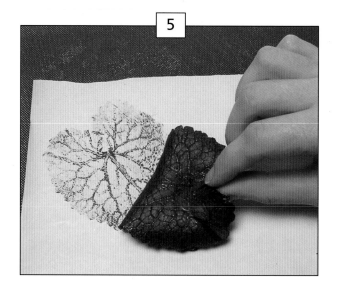

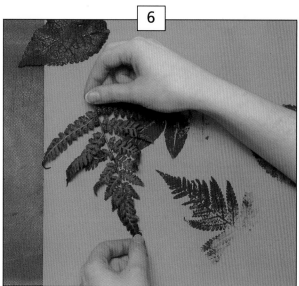

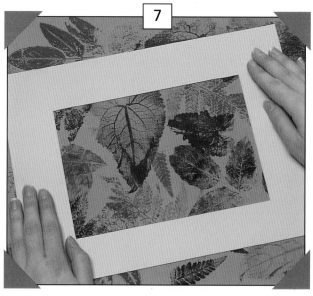

4 Press down on the paper with both hands. You could roll over it with a roller if you have another clean one.

5 Carefully peel off the leaf to leave a print behind.

6 When you are ready, you can print the leaves onto your colored paper. Use another color as well and print until your paper is covered with leaves.

7 **To make a frame, cut a rectangle in a piece of cardboard the size you want your finished picture to be.** Use your frame to select the part you think is best.

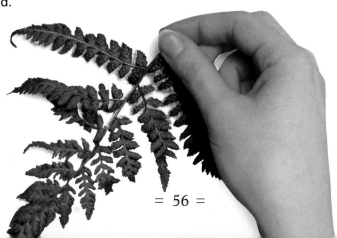

8 **Cut the picture out** and glue it behind the frame.

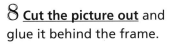

**TIP**

☛ Print from some other flat things such as squashed soda cans.

# Fruit and Vegetable Giftwrap

Make your own wrapping paper by printing with fruit and vegetables. It will make your gift more exciting to look at and more personal to receive.

## YOU WILL NEED

- Kitchen knife
- Various fruit and vegetables: e.g. cucumber, apples, lemon, bell pepper, cabbage, onion, leek, celery, tomato, carrots
- Paper towels
- Ready-mixed paint (green, blue, red, brown)
- Plastic lids
- Pieces of cardboard
- Paintbrush
- Newsprint
- Colored paper (yellow)

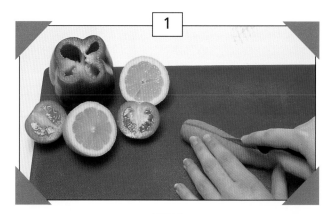

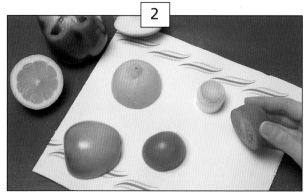

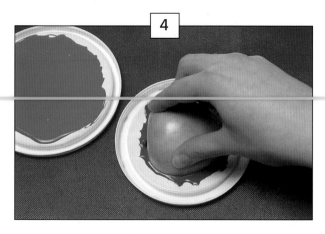

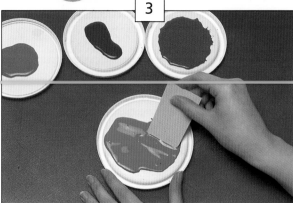

**TIP**

☛ Try pressing your fruit or vegetables into craft glue and print onto black tissue paper. Sprinkle glitter on while the glue is wet.

1 <u>Cut your fruit and vegetables in half. Cut lemons and similar fruit across the middle. Cut apples or similar through the ends.</u>

2 Some of them may need drying. Stand them on their cut end on some paper towels.

3 Put small amounts of paint onto plastic lids. Spread the paint with pieces of cardboard.

4 Press your cut fruit or vegetables into the paint.

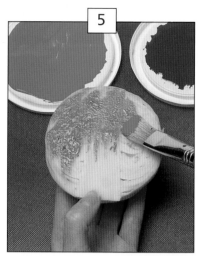

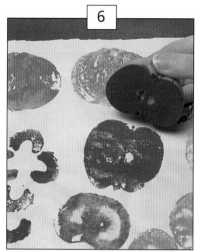

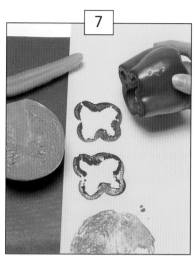

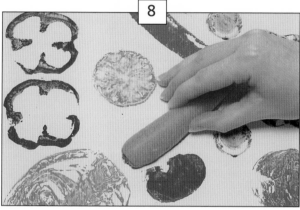

5 Use a brush to put the paint on, if necessary, if the object is too large for your paint container.

6 Experiment on newsprint to see what shapes you can make. Press the fruit or vegetable onto the paper.

7 Then print onto the colored paper.

8 Combine shapes and colors to make patterns for your wrapping paper.

# Sponge-Print Bag

Print your own cloth and make a bag for keeping all kinds of things in.
You will enjoy using it simply because you have made it.
It can also be a great gift.

## YOU WILL NEED

- Scissors
- Pieces of sponge (not the real sort)
- Black felt-tipped pen
- Shallow containers
- Acrylic paint (we used iridescent colors, but any acrylic will do)
- Paper
- Iron
- Ironing board
- A piece of muslin or other cotton cloth 12 x 28 inches
- Needle and thread
- Clothespins
- Safety pin
- Two pieces of cord or fabric tape, 30 inches long
- Scraps of fabric

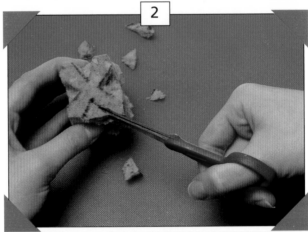

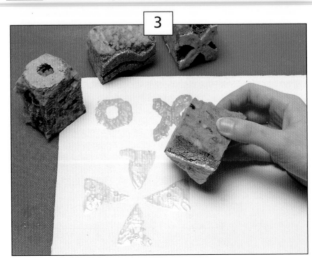

1 **Cut the sponge into 2-inch squares.** Draw the shape you want onto the top of the square with a felt-tipped pen. Keep the shapes simple.

2 **Cut the shape out with scissors by carefully snipping the sponge.**

3 Pour some paint into the shallow containers and stamp the cut shape into the paint and print it on some paper. Try out each of your shapes. Combine them to make different patterns.

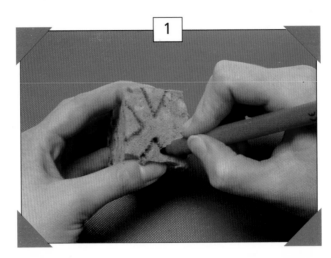

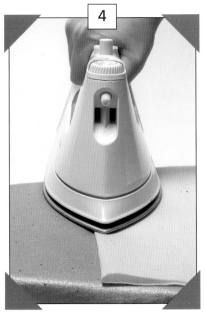

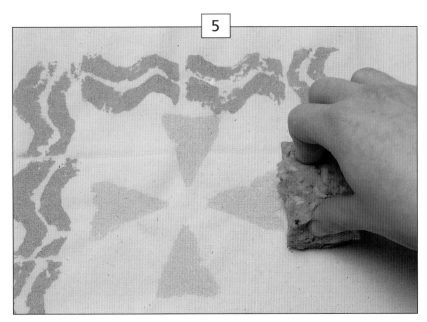

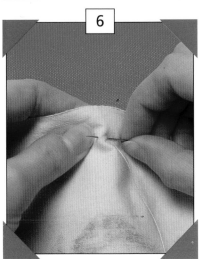

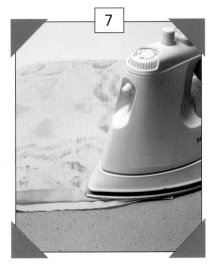

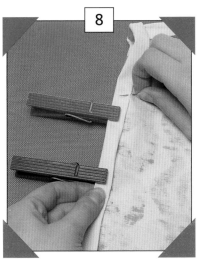

4 **Set the iron to a cotton setting. Iron the piece of cloth flat (with an adult present). Fold the cloth in half and iron flat.** Then open out the cloth so that you can see where both sides are.

**TIP**

☛ You can try printing on other fabrics. Make a scarf perhaps. Use some fabric paints.

5 Now that you have decided on a pattern, you can print your cloth. Put some paper underneath to stop the color from damaging your working surface. Leave a margin of at least ¾ inch down each of the long sides. Leave at least 1½ inches at the top and bottom. Allow the paint to dry.

6 Fold the cloth in half again, with the printed side facing in. **Sew up the sides ¾ inch from the edge.**

7 Fold the top edges over ½ inch and **iron flat**.

8 Then fold them over ¾ inch and **iron flat**. Sew along the bottom edge of these folds. You can use clothespins to hold the cloth in place.

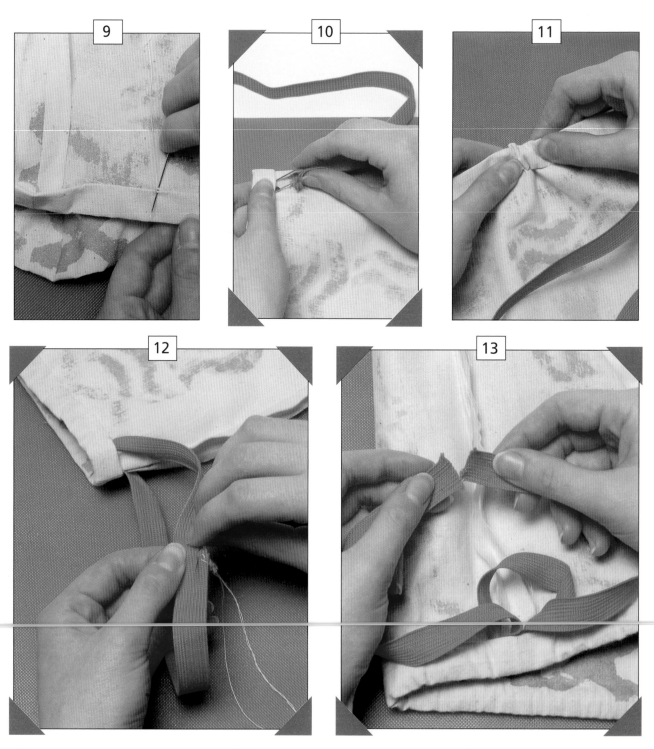

9 Leave a 1½-inch gap at each side edge. This is where the cord or tape will go.

10 **Fasten a safety pin onto the end of one of the pieces of cord or tape.**

11 Thread it through all the way around the top.

12 **Sew or tie the two ends together.**

13 Now thread your other piece of cord or tape through, so that the ends come out at the opposite side. **Sew or tie these ends.**

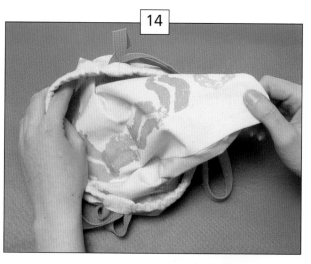

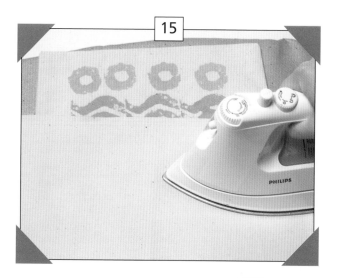

14 Turn the bag so that the pattern is on the outside.

15 Cover the bag with a scrap of material and **iron flat**. When you pull the tapes, the bag will close.

# Cover Up

Make your own printing block from string to print a book cover.
Not only will you enjoy making it, your favorite books will be kept clean,
and be just yours.

## YOU WILL NEED

- Craft glue
- String
- Scrap cardboard
- Scissors
- Printing ink (blue)
- Sheet of glass or plastic (inking plate)
- Printing roller
- White paper
- Ruler and pencil

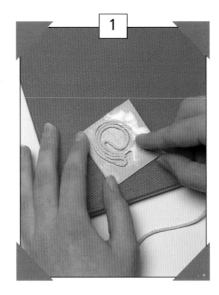

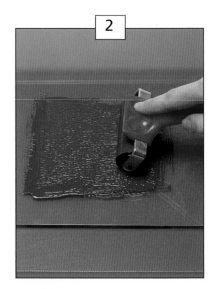

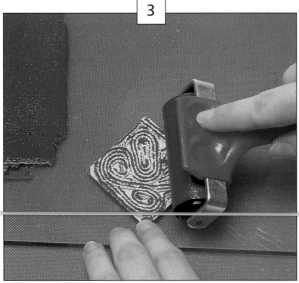

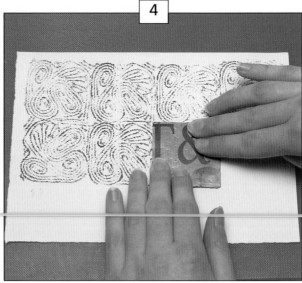

1 Use craft glue to stick your string on a 2-inch square of cardboard. You can draw your pattern on first as a guide. Make continuous spiral shapes, **or cut the string into short lengths for straight lines.** Leave the glue to dry.

2 Squeeze some printing ink onto your inking plate. Roll the ink with your roller until it is spread evenly.

3 Roll the ink over your string printing block until it is completely covered.

4 Now try printing on some paper. Place the block face down on the paper and press down evenly all over. Inspect your print. You may need to use more or less ink. As you take more prints, the color will get stronger.

**5**

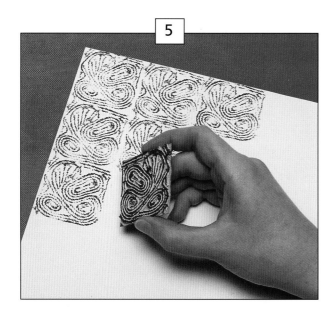

**6**

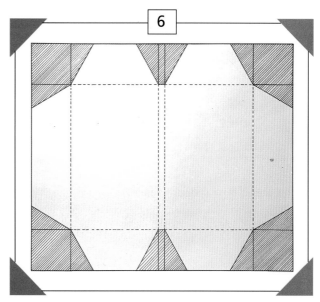

**7**

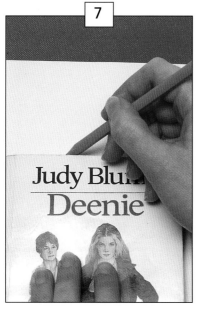

**8**

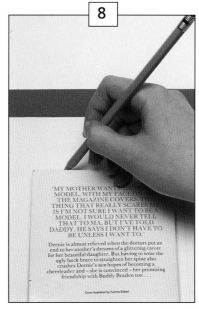

**9**

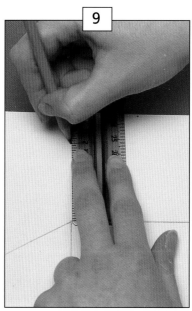

5 When your block is printing well, you can print the paper for your book cover. Your piece of paper needs to be at least 2 inches bigger than your open book. Don't forget to add the width of the spine in your measurements.

6 This diagram shows what your book cover should look like. **<u>The shaded areas on the diagram show which pieces should be cut away, leaving the flaps.</u>**

7 When the printing ink is dry, turn the paper over. Place the spine of the book in the center of the paper. Draw around one side of the book.

8 Then carefully turn the book over and draw around the other side. Remember to allow for the width of the spine of the book.

9 Measure 2-inch flaps using the diagram as a guide.

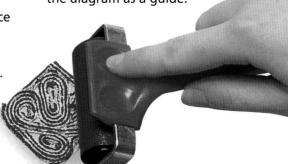

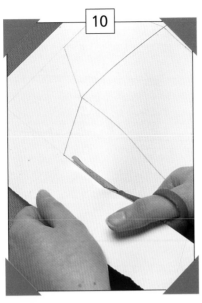

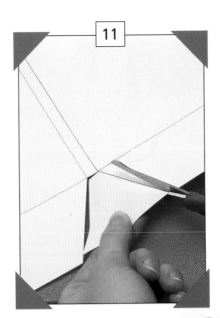

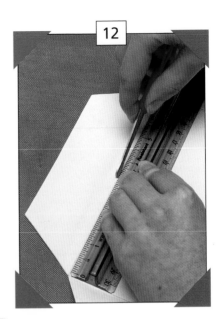

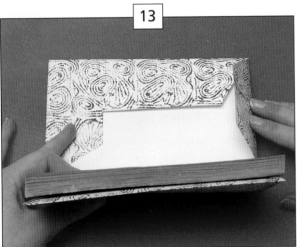

10 <u>**Begin to cut out your book cover.**</u>

11 <u>**Cut away the areas which
are shaded.**</u>

12 <u>**Score along the lines which are
shown dotted in the diagram.**</u>

13 Fold the printed cover over
your book.

**TIP**

☛ Make another string
block and overprint on
your cover with a
contrasting color.

# Night and Day Box

Open your box of moon and stars to see the sunshine inside. Keep your precious things in there, or use it to make a gift extra-special.

### YOU WILL NEED

- Black felt-tipped pen
- Corrugated cardboard
- Craft knife
- Craft glue
- Empty cereal box
- Sheet of thin white cardboard 10 x 12½ inches
- Pencil and ruler
- Scissors
- Printing roller
- Sheet of glass or plastic (inking plate)
- Printing ink (blue, orange)
- Clothespins

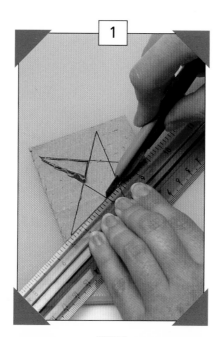

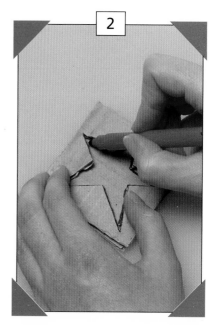

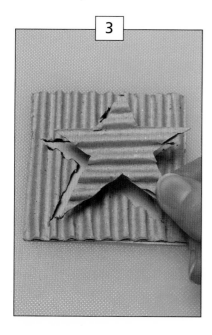

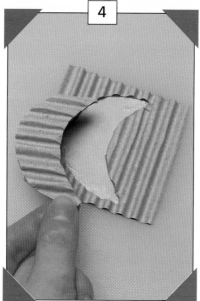

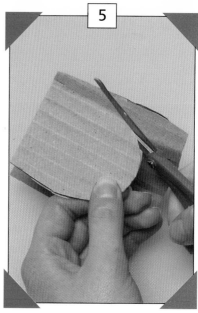

1 Draw a star shape on the flat side of a 3-inch square of corrugated cardboard. **Cut out the star with a craft knife** to leave a star-shaped hole.

2 Draw through the star-shaped hole onto the flat side of another piece of corrugated cardboard. Make sure the grooves run in the opposite direction, **cut out the star.**

3 Glue the cardboard with the star-shaped hole onto a 3-inch square of cereal box, and glue the star into the empty shape.

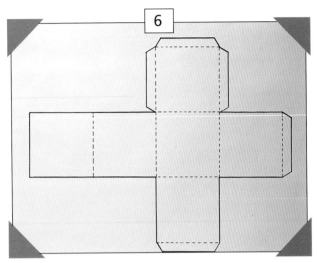

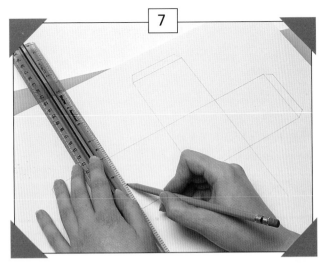

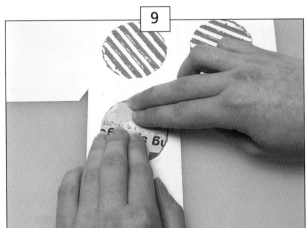

4 **Repeat the first three stages, but this time with a moon shape.**

5 **Cut out a 2-inch diameter circle** to represent the sun and glue it onto a flat piece of cardboard.

6 This diagram shows the shape you need to **cut out of your thin white cardboard.**

7 Draw on the cardboard the six 3-inch squares with 1½-inch flaps. You can use the template on page 94. **Cut out the shape.**

8 Roll some yellow or orange ink onto your inking plate. Roll over the sun shape.

9 Place it in the center of a square of your cutout box. Repeat for each square on one side of your cutout box.

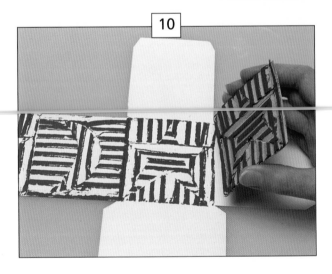

10 Roll over star and moon shapes with blue ink and print the other side of the box with the star and moon shapes, alternating the shapes.

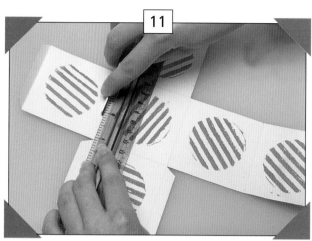

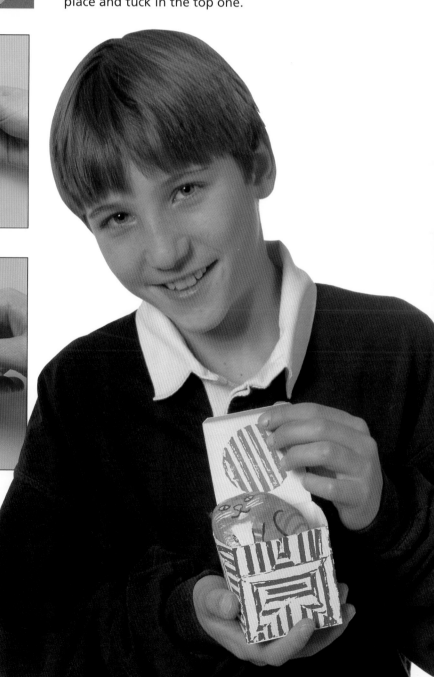

**11** When this is dry, <u>**score along the dotted lines in the diagram on the "day" side**</u> and fold up the box with the "night" on the outside.

**12** Glue the side tab first, using clothespins to hold it together while the glue dries.

**13** Glue the bottom tabs in place and tuck in the top one.

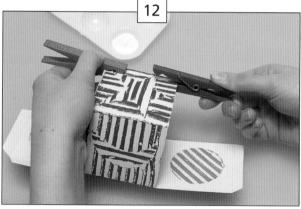

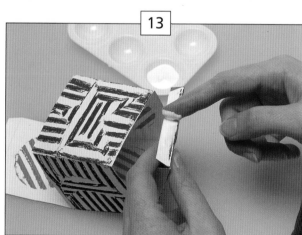

## TIP

☞ Make other boxes using different shapes; hearts, clubs, diamonds, and spades, for example.

CHAPTER FOUR

# Mono Printing

. . . . . . . . . . .

# Bug Masks

Use this intriguing technique to make these curiously insect-like masks.

## YOU WILL NEED

- Paper approximately 9 x 11 inches
- Cotton thread 16 inches long
- Shallow containers
- Ready-mixed paint (red, blue, black)
- Paintbrush
- Water
- Scissors
- Stapler
- String 2 x 15 inches

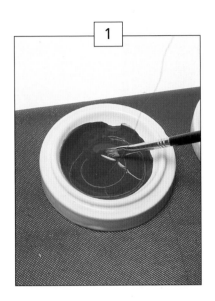

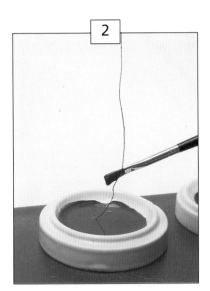

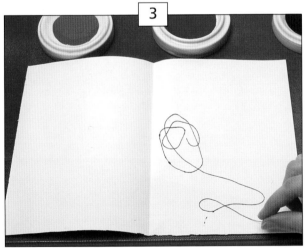

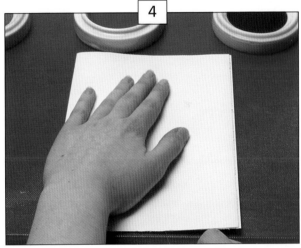

1 Fold the paper in half on the longest side then open it again. Put some different colored paints into the containers. The paint should be watered down just enough to make it runny. Hold one end of the thread and dip it in the paint. Push it under with a brush.

2 As you pull the thread out of the paint, let it run over the brush to remove any excess paint. This also straightens the thread.

3 Bring the thread out, fully covered with paint, and drop it onto one side of the folded paper. Hold one end and leave it hanging over the edge of the paper.

4 Fold the paper over and press down. Keep pressing with one hand and pull the thread out with the other. Pull toward the corner to make the shape wider.

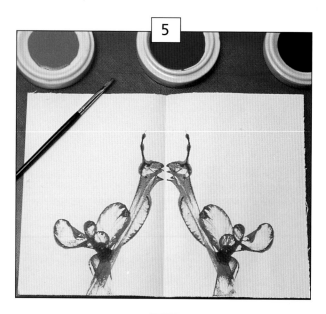

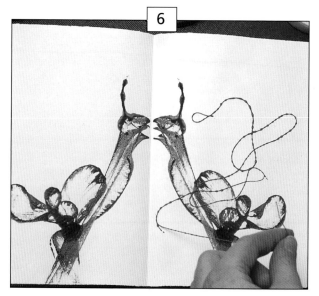

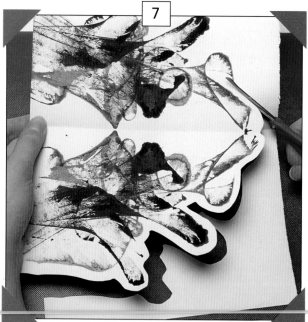

5 Open your print.

6 Repeat the process with the other chosen colors.

**7 <u>Cut out a mask shape, leaving a gap around the edge of the print.</u>**

8 Tie a knot in one end of each length of string. Staple a string to each side of the mask.

**TIP**
☛ These would look good on your wall as decoration.

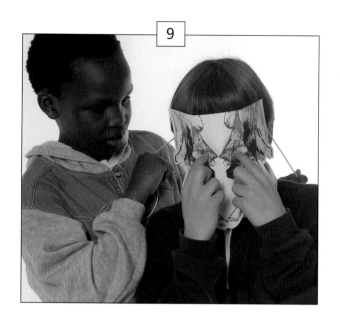

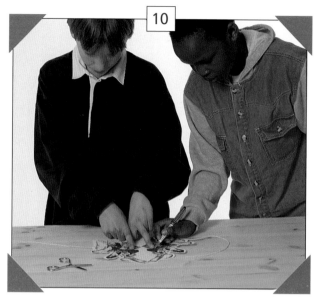

9 Try the mask on. Tie the strings at the back. Feel carefully where the eye holes need to be.

10 Remove the mask and mark with a pen where the eye holes need to be **and cut out small circles.**

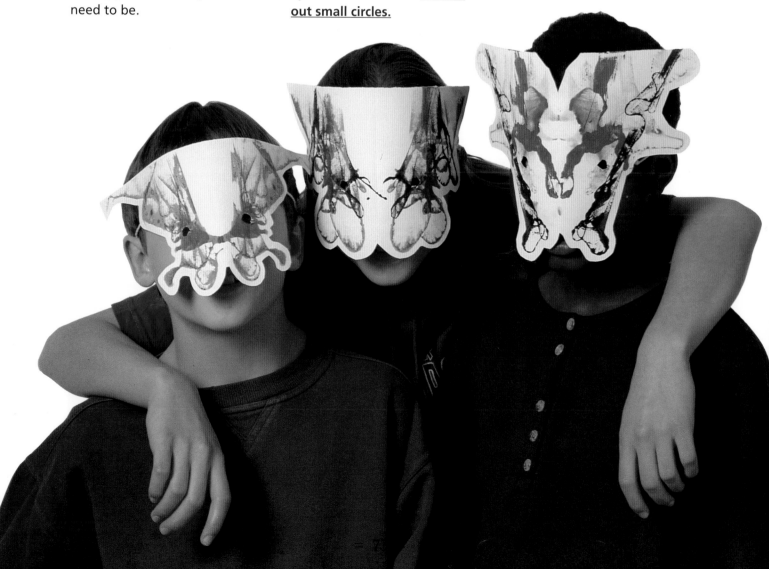

# Radical Robot

See what interesting odds and ends you can find
to build up this robot print.

**YOU WILL NEED**

- Various scrap objects:
  cardboard tubes, boxes,
  odds and ends
- Shallow tray for paint
- White acrylic paint (or silk
  vinyl latex)
- Black paper
- Paintbrushes
- Small container for inks
  Colored inks (blue, red)

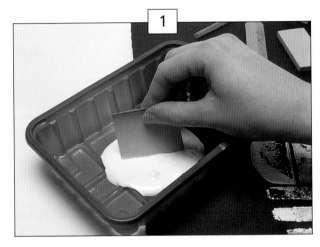

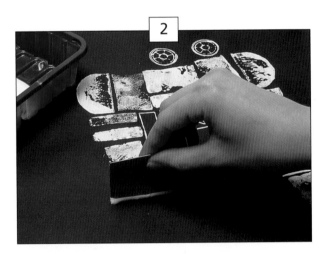

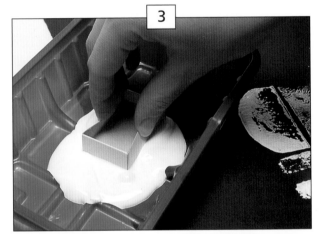

1 Pour some white paint into the shallow tray.
Build up the robot's body by printing with the
boxes, tubes, etc. Dip each object in the paint.

2 Press the object onto the paper. See what
kind of shape it makes.

3 You can use small objects like keys, clothespins,
a small box or empty spools for the robot's inner
workings and use a slightly larger box for his
legs. (You can wash the objects afterward.)

4 Gradually use more objects to build up
your robot.

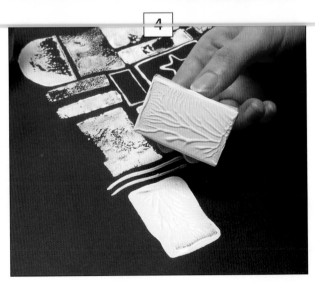

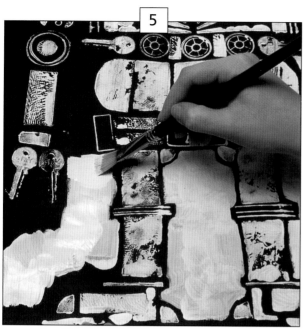

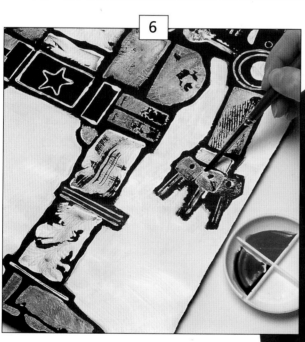

5 When you have finished printing, paint the background with white paint, leaving a black line around the robot.

6 When the white paint is dry, you can put thin washes of colored inks over the top where you feel it is needed.

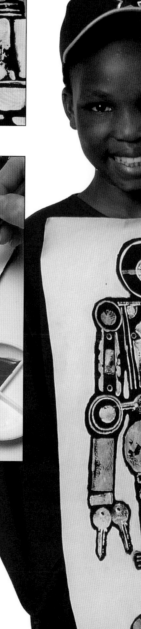

# Floating Butterfly

Enjoy squelching the colors in these big prints. Hang them on your bedroom wall as colorful decorations.

## YOU WILL NEED

- Large sheets of newsprint
- Pencil
- Scissors
- Ready-mixed paint (yellow, black, red, white)
- Water
- Tape
- Thin garden stake
- Strong thread

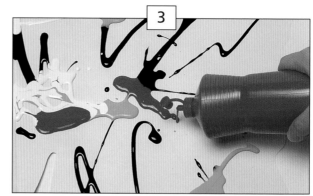

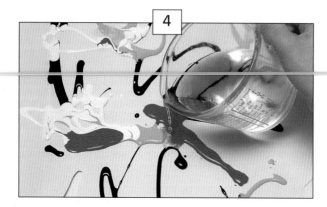

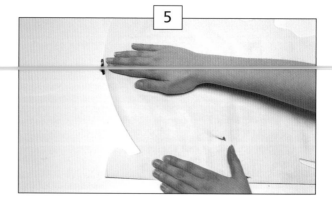

1 Fold a sheet of newsprint in half. Draw half a butterfly so that it fills the paper as much as possible. Make sure the center (the body) of the butterfly is on the fold.

2 **Cut out the shape and open up the paper.**

3 Squeeze some colors across one side and along the center of your butterfly.

4 Add some splashes of water, too.

5 Fold the paper over again.

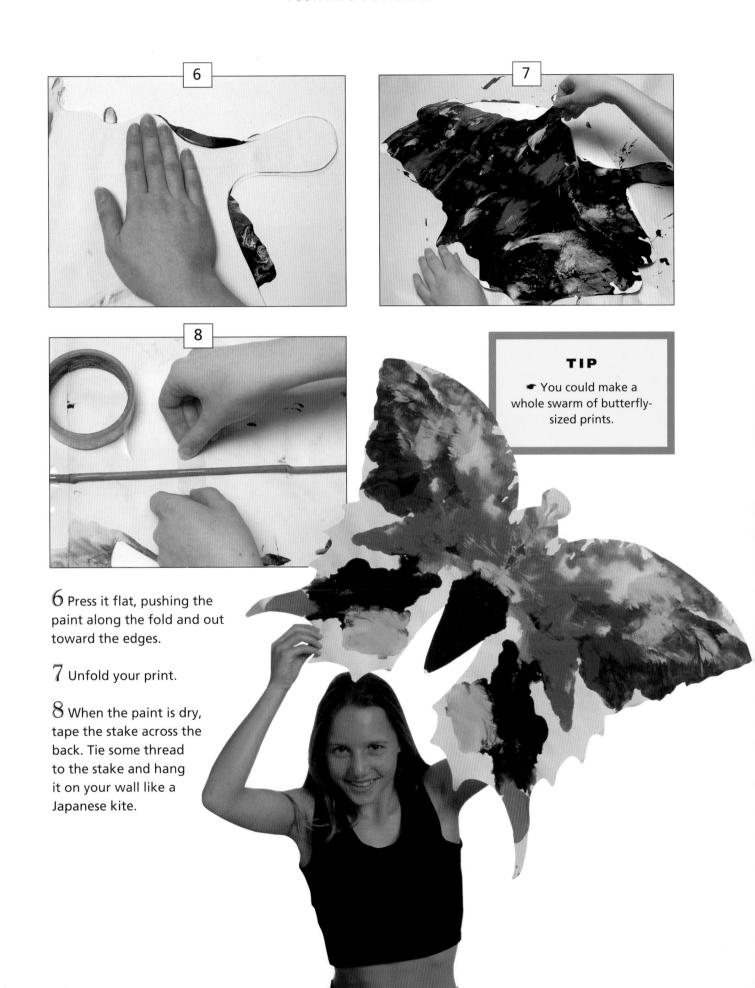

6 Press it flat, pushing the paint along the fold and out toward the edges.

7 Unfold your print.

8 When the paint is dry, tape the stake across the back. Tie some thread to the stake and hang it on your wall like a Japanese kite.

**TIP**

☞ You could make a whole swarm of butterfly-sized prints.

# Tiger, Tiger

A two-color monoprint method that allows you to work in as much detail as you want. Fill the jungle with animals and plants.

## YOU WILL NEED

- Paper
- Sheet of glass or plastic (inking plate)
- Printing roller
- Printing inks (orange, green)
- Scrap paper
- Pencil

1 Put a sheet of paper under your inking plate, so that you can see how big an area you need to ink up. Roll up your plate with your first color.

2 Don't put too much color on. Let that dry slightly – blot it off with scrap paper.

3 Place a sheet of paper on top of the ink. Draw on the paper with a pencil, holding onto it at the edge to keep it still. Try to keep your hands off the paper. Hold the pencil upright when you draw.

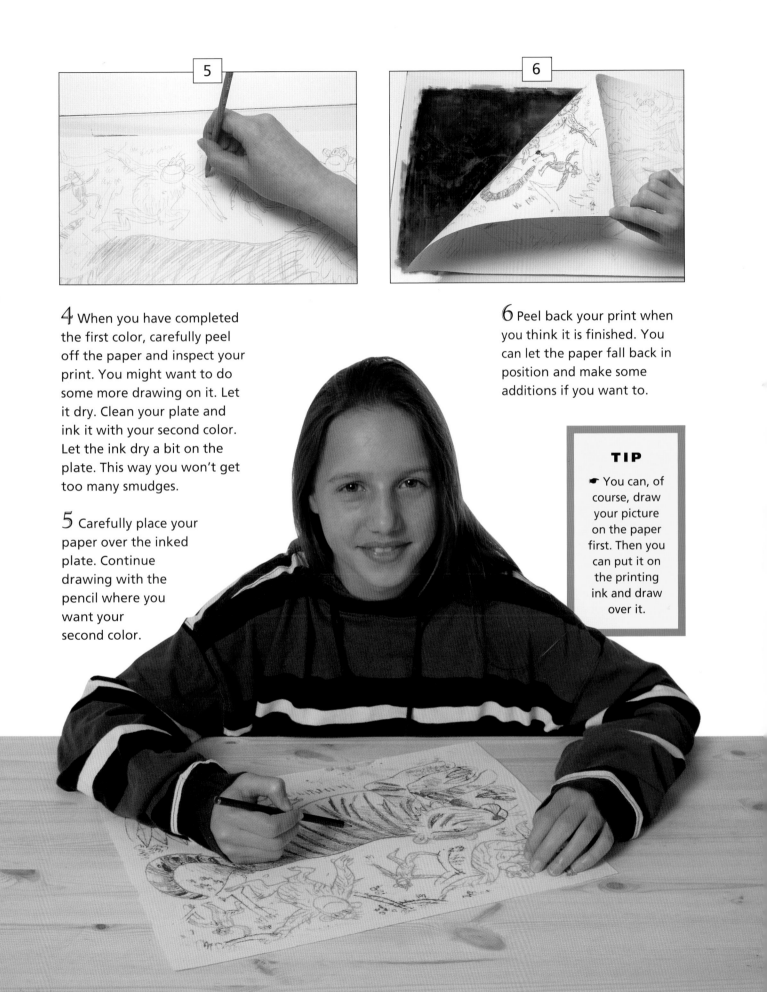

4 When you have completed the first color, carefully peel off the paper and inspect your print. You might want to do some more drawing on it. Let it dry. Clean your plate and ink it with your second color. Let the ink dry a bit on the plate. This way you won't get too many smudges.

5 Carefully place your paper over the inked plate. Continue drawing with the pencil where you want your second color.

6 Peel back your print when you think it is finished. You can let the paper fall back in position and make some additions if you want to.

**TIP**

☞ You can, of course, draw your picture on the paper first. Then you can put it on the printing ink and draw over it.

# Four Seasons Calendar

Use mono prints to illustrate the changing seasons. Hang the calendar at home or make it a New Year's gift.

## YOU WILL NEED

- Pieces of paper approximately 5½ x 9 inches
- Sheet of glass or plastic (inking plate)
- Shallow containers
- Ready-mixed paint (assorted colors, red, brown, yellow, blue, green, orange, white)
- Paintbrushes
- Jar of water
- Paper towels
- Newsprint
- Paper (for frames)
- Pencil
- Scissors
- Glue stick
- Four sheets of black cardboard 9 x 11 inches
- Printed calendar
- Hole punch
- Ribbon

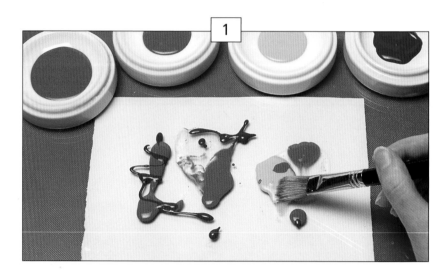

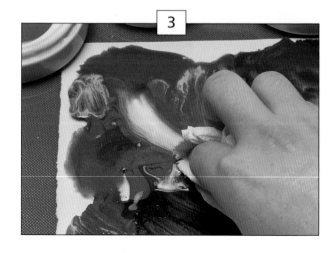

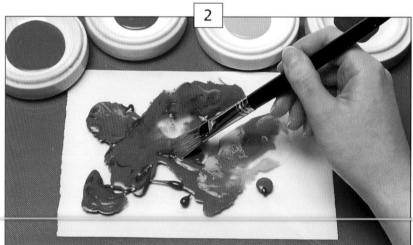

1 Begin with the picture for Fall. Put a piece of paper under your inking plate, so that you can see how big your picture is going to be. Paint some fall colors onto your inking plate.

2 Push the colors around with your brush until you think it looks about right.

3 You can also use paper towels, cardboard, or even your fingers to clear areas and to make different shapes.

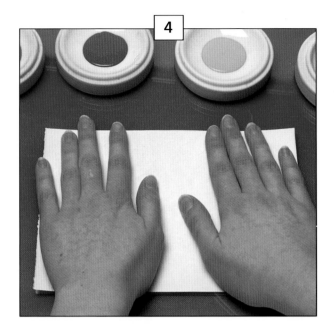

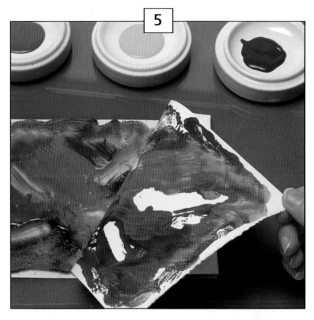

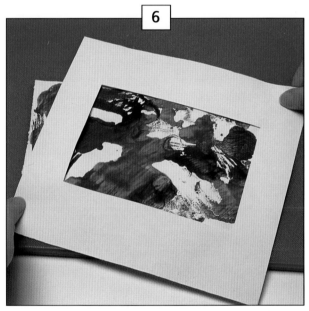

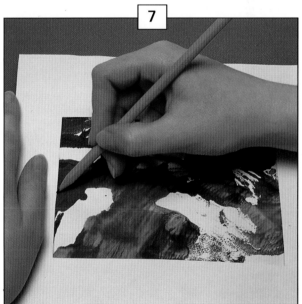

4 While the paint is still wet, lay a sheet of paper over it. Press down all over the paper.

5 Gently peel off your print from one side. You can make a number of different prints. Go on to make prints for the other seasons, choosing the most expressive colors. See pictures on page 83.

6 Choose your favorite print for each season. You can make a small frame to help you to select the best part of that print. Make the frame out of a piece of paper about 6 x 8 inches. Out of this, cut out a rectangle 4 x 6 inches.

7 Put the frame over your favorite part and draw around the inside rectangle.

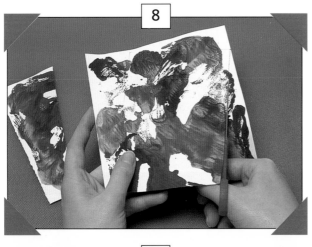

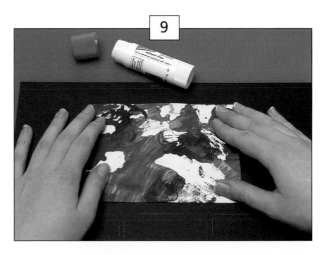

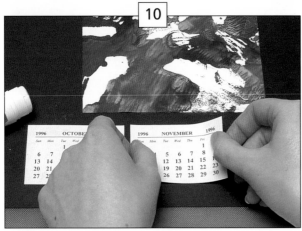

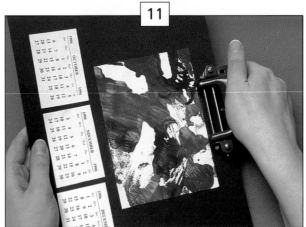

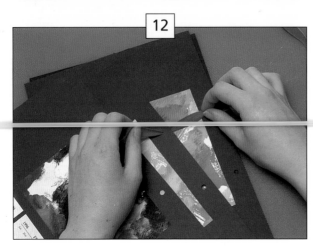

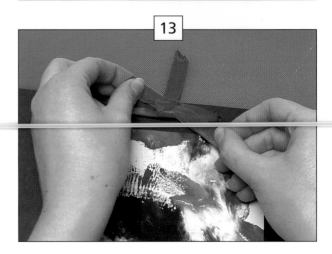

8 **Cut out the selected part.**

9 Glue each print onto a sheet of black cardboard, in the middle and about an inch from the top.

10 Place the appropriate three calendar months evenly underneath and stick down.

11 Punch holes in the center of the top of the four pieces of black cardboard.

12 Assemble them with the ribbon, in the right order, January to December.

13 Finish with a bow.

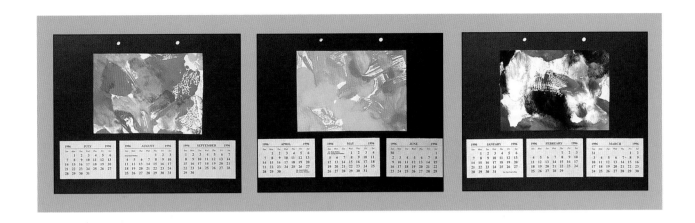

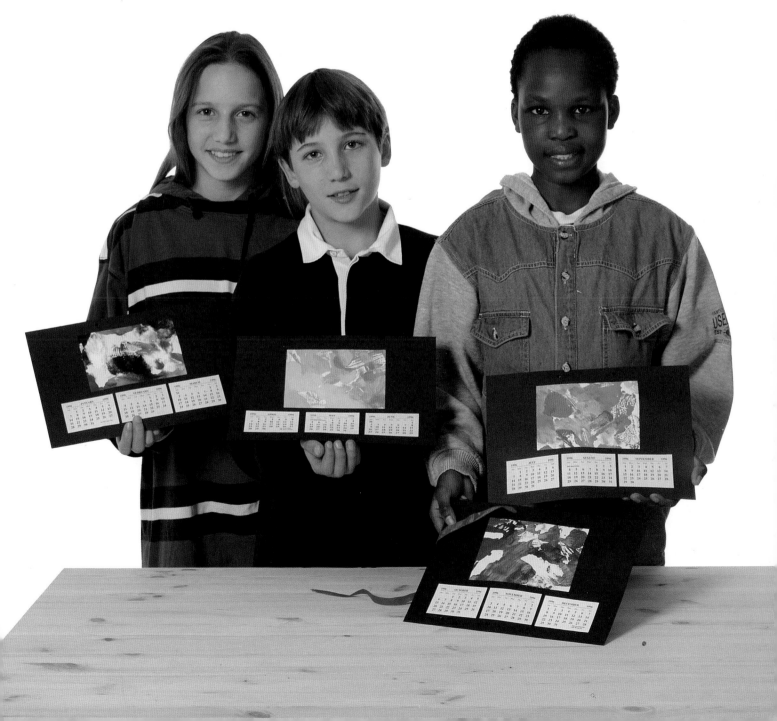

# Bubble Bag

A fun method of printing that has fascinating results . . . and a way of making gift bags you can use again and again.

## YOU WILL NEED

- Dishwashing detergent
- Ready-mixed paint (black)
- Water
- Plastic containers
- Paintbrush
- Drinking straws
- White paper
- Colored paper
  11½ x 16½ inches
- Pencil and ruler
- Double-sided tape
- Hole punch
- Cord

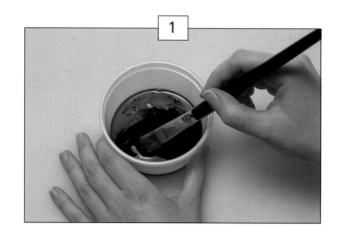

1 Mix some liquid detergent, ready-mixed paint, and a little water in a plastic container, and stir with a brush.

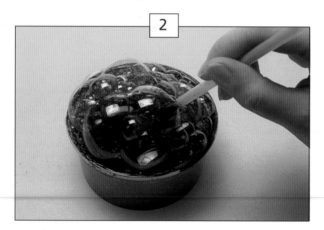

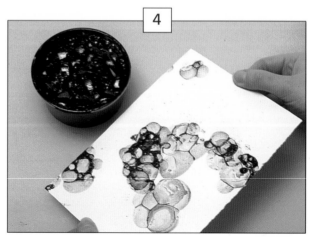

2 Put a straw in the paint and blow bubbles, until they start coming over the top of the container.

3 Practice the technique by holding a sheet of white paper with both hands and gently touch the bubbles with it.

4 Roll the paper around so that you catch all the bubbles. Let the bubbles burst on their own. When you have mastered the technique, print all over the colored paper.

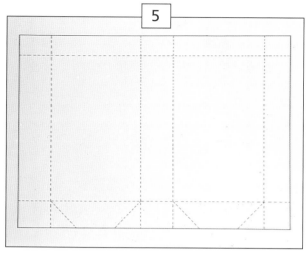

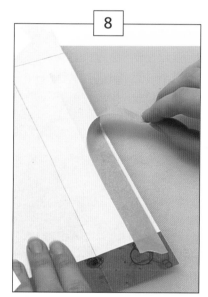

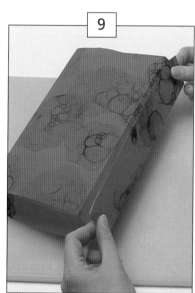

5 The diagram shows where the folds need to be to make the bag.

6 When the paper is dry, turn it over and draw lines as shown in the diagram, or trace the diagram from page 96.

7 **Score the dotted lines and fold them firmly.**

8 Fold along the bottom line and stick down with double-sided tape. Now put the double-sided tape along one side.

9 Stick the two sides together with double-sided tape.

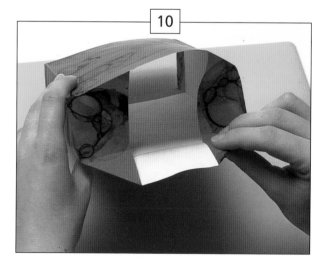

10 Fold the bottom ends over along the scores.

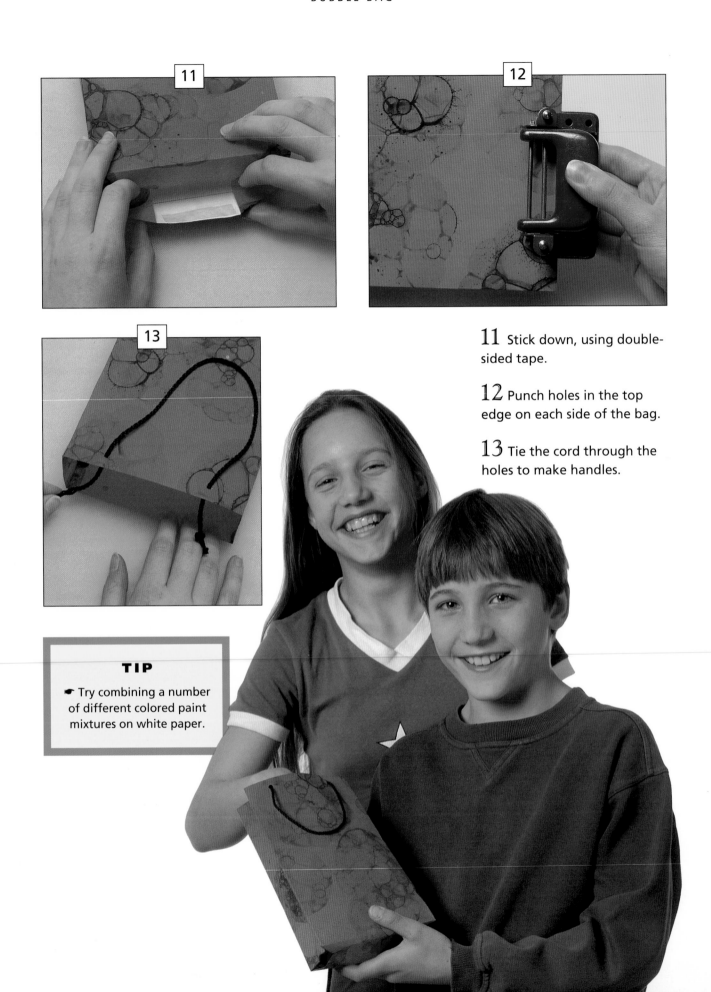

**11** Stick down, using double-sided tape.

**12** Punch holes in the top edge on each side of the bag.

**13** Tie the cord through the holes to make handles.

**TIP**

☞ Try combining a number of different colored paint mixtures on white paper.

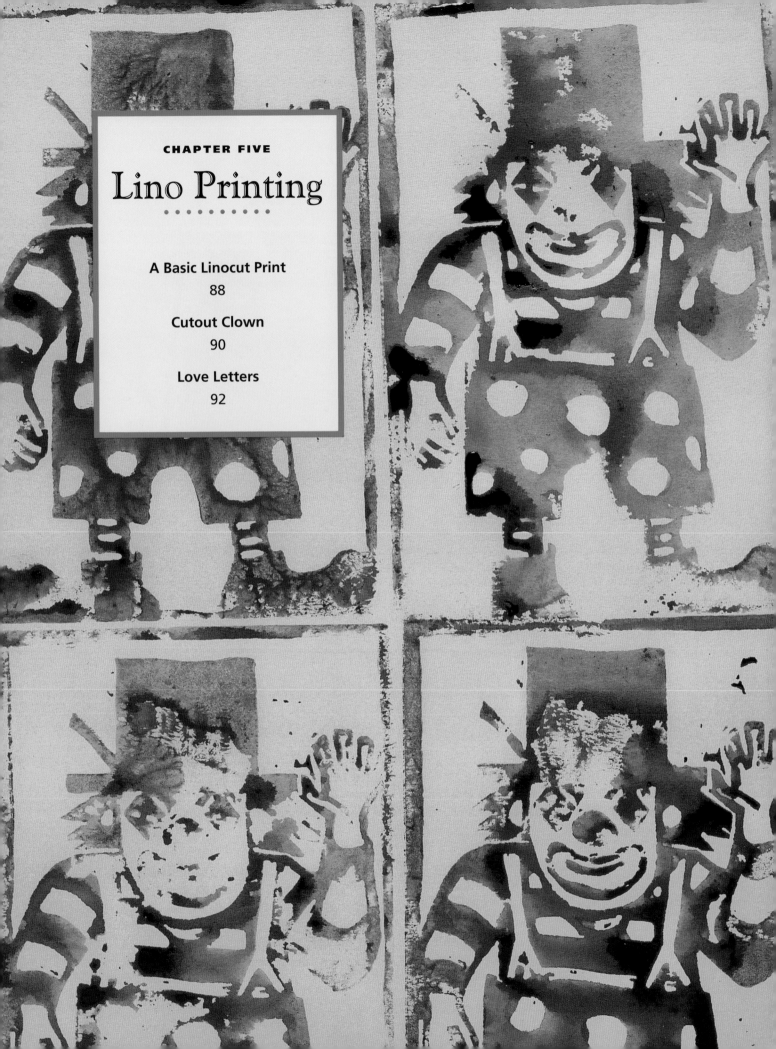

# A Basic Linocut Print

Follow the steps and you will learn a technique that will open up
all sorts of print possibilities.

**YOU WILL NEED**

- Pencil
- Linoleum for printing
- India ink
- Brush
- Bench hook
- Set of linoleum cutters
- Printing ink (green)
- Sheet of glass or plastic
  (inking plate)
- Printing rollers
- Water (optional)
- Newsprint
- Spoon

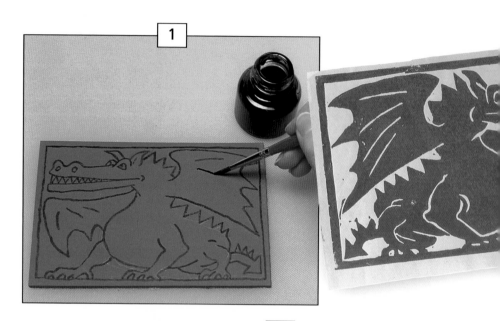

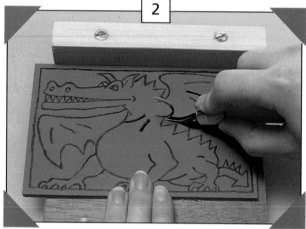

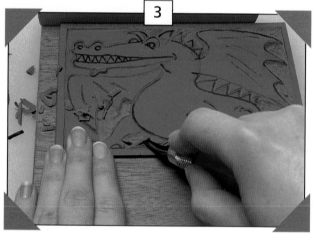

1 Decide on your design and draw it on your
linoleum block in pencil. Keep it nice and bold.
Go over the design with India ink on a brush as
the pencil will rub off.

2 To stop your linoleum block from slipping, it's
a good idea to make what is called a bench
hook. It can be made from scraps of wood. It fits
over the edge of your table, and you push your
linoleum block up against the top edge of it.
See page 9. **In a linocut block, you must cut**
**away all the parts you want to remain white in**
**your print. Use the V-shaped tools to cut out**
**lines and to cut around shapes.**

3 **The U-shaped tools are used to clear away**
**large areas. Try not to dig into the linoleum.**
**Turn the block as you cut, so that you always**
**cut away from yourself. Keep the hand holding**
**the linoleum close to you, and never in the path**
**of the cutter.** Follow any instructions you
received with your linoleum cutting tools.

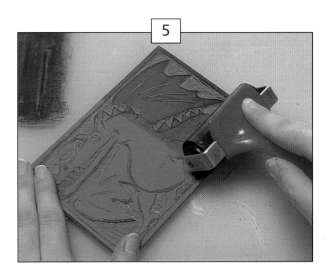

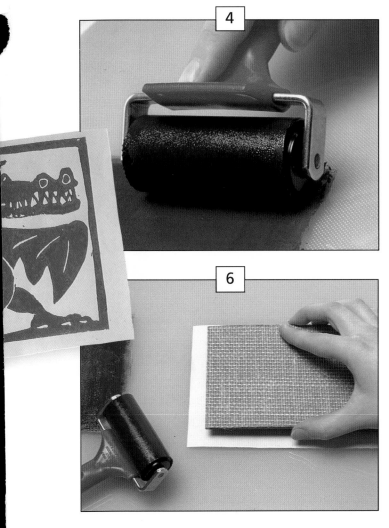

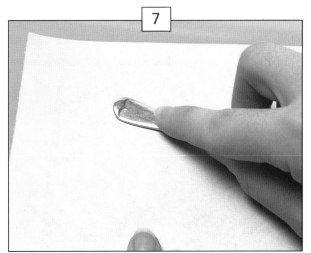

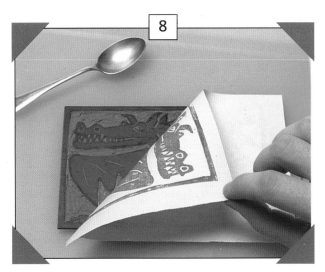

4 When you're ready to print, put some ink on your inking plate and roll over it back and forth until it is evenly spread out. You can add a little water if the ink is too thick.

5 Now, roll your inked roller over your linoleum block until the ink is evenly spread over the parts that are left uncut.

6 Lay the block face down on a piece of newsprint. Press it down evenly, or roll it with a clean roller.

7 Carefully turn over the paper and block. Holding the paper still, rub all over the paper with the back of a spoon in a circular motion. You can peel the print back from a corner to see how it is going.

8 When you have finished, peel the print off carefully. Inspect it to see if you need to adjust the ink or the rolling next time. **<u>Maybe you need to cut away some more linoleum.</u>**

# Cutout Clown

Make your own greeting cards with your own personal message. There is a template you can use to help you.

**YOU WILL NEED**

- Scissors
- Thin cardboard
- Envelopes
- Tracing paper
- Carbon paper
- Linoleum blocks
- Linoleum cutters
- Printing rollers
- Printing inks (black, red)
- Gummed paper shapes

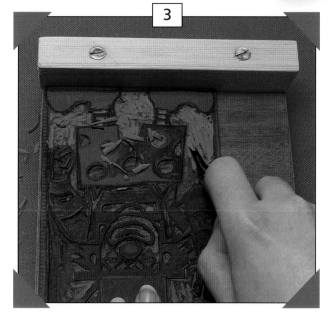

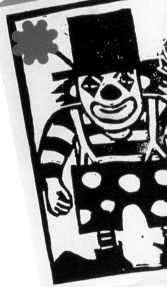

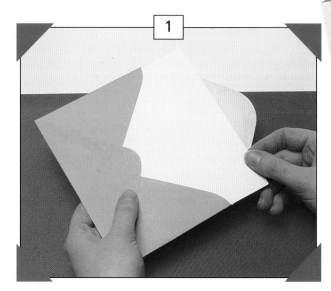

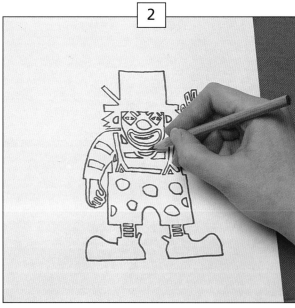

1 **Cut your cardboard into rectangles big enough for the clown on the template to fit.** Make sure that, when they are folded in half, they will fit in the envelopes.

2 Trace the template from page 95. Use carbon paper to transfer the tracing onto your linoleum block.

3 **Follow the instructions for cutting out your linoleum block on page 88.**

**TIP**

☛ Now draw your own design for your next greeting card.

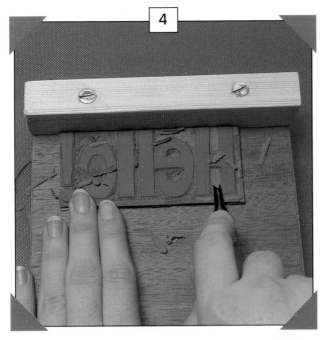

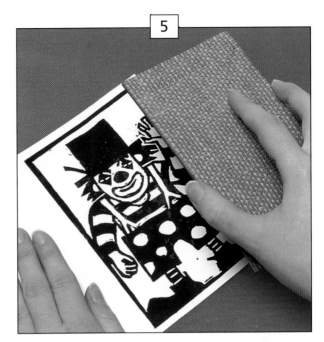

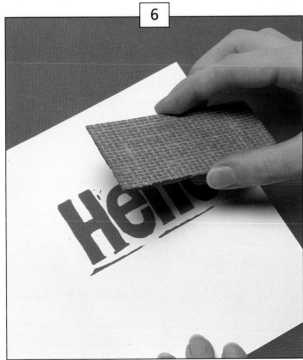

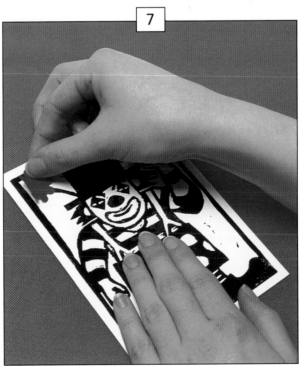

4 Now draw and **<u>cut out a block</u>** for a greeting inside the card. Remember the letters and the word must be made back to front.

5 Fold your cards in half, then press them out flat again. Put some ink on the inking plate and roll it out as shown on page 89. Print the outside of the cards first.

6 When they are dry outside, print the insides with a different color.

7 Fold the cards again and stick on a gummed shape for the clown's flower.

# Love Letters

Use a linocut to make your own personal stamp and make your stationery and envelopes your very own.

**YOU WILL NEED**

- India ink
- Paintbrush
- Linoleum
- Bench hook
- Linoleum cutters
- Scissors
- Craft glue
- Small block of wood
- Ink pad (from stationery stores) (red ink)
- Stationery
- Colored envelopes

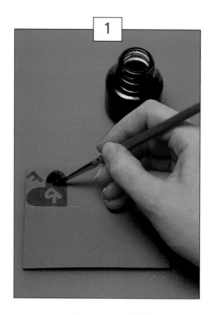

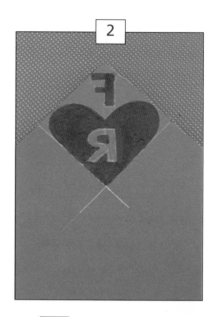

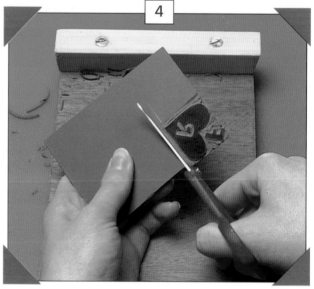

1 Design a stamp based on your initials and a simple shape. Make your design about 1¼ x 1¼ inches.

2 Remember to write the letters backward. Draw the design on the linoleum with India ink. Refer to the previous project on page 90. It will be easier to cut out if you do it on the corner of a bigger piece of linoleum.

3 **Cut out your design with the linoleum cutters.**

4 **Then cut the square of linoleum off using the scissors.**

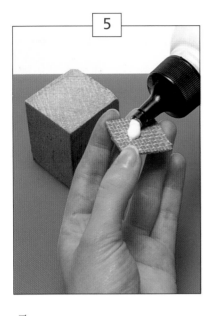

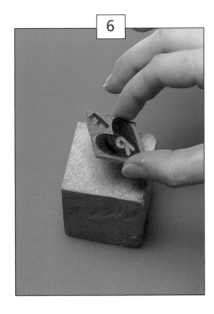

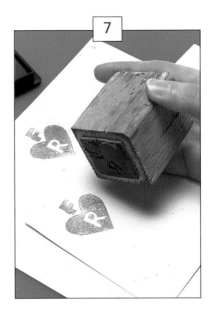

5 Spread some white craft glue across the back of the linoleum block.

6 Glue the square of linoleum to the block of wood.

7 With your ink pad, you can now stamp your stationery and envelopes with your own personal logo.

**TIP**

☛ Use your personal stamp on the inside cover of your books, too.

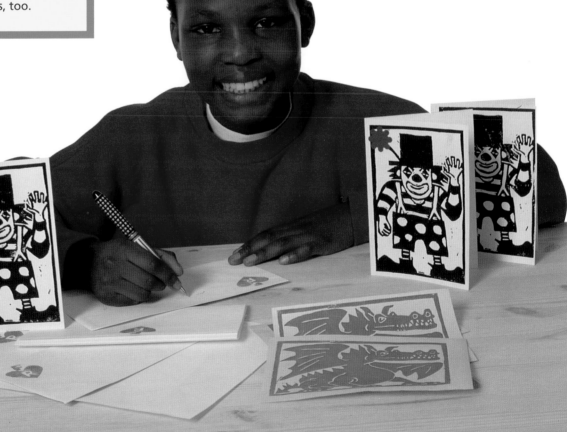

# Templates

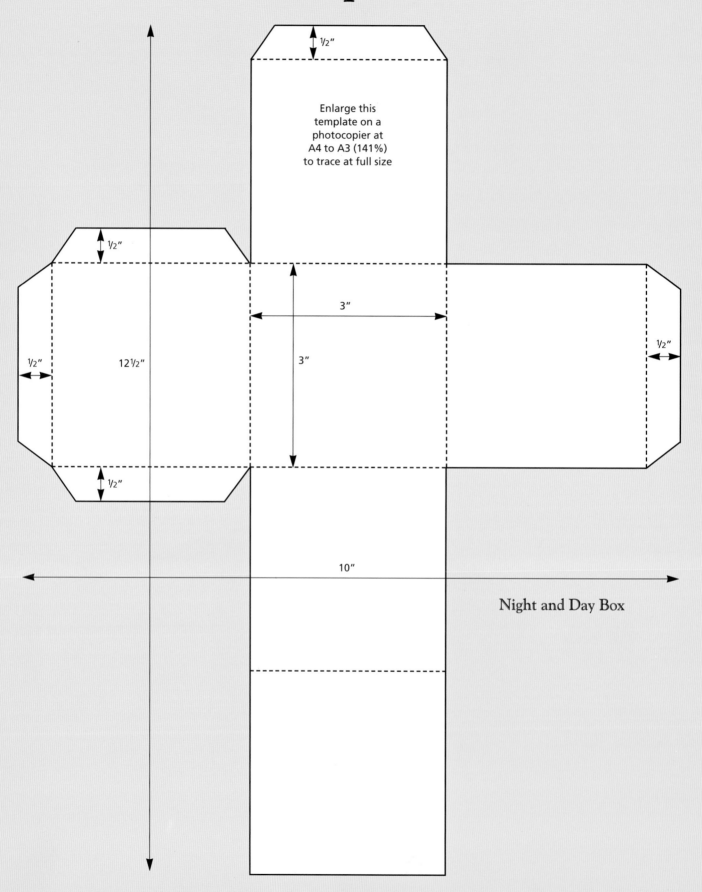

½"

Enlarge this
template on a
photocopier at
A4 to A3 (141%)
to trace at full size

½"

½"

3"

12½"

3"

½"

½"

10"

Night and Day Box

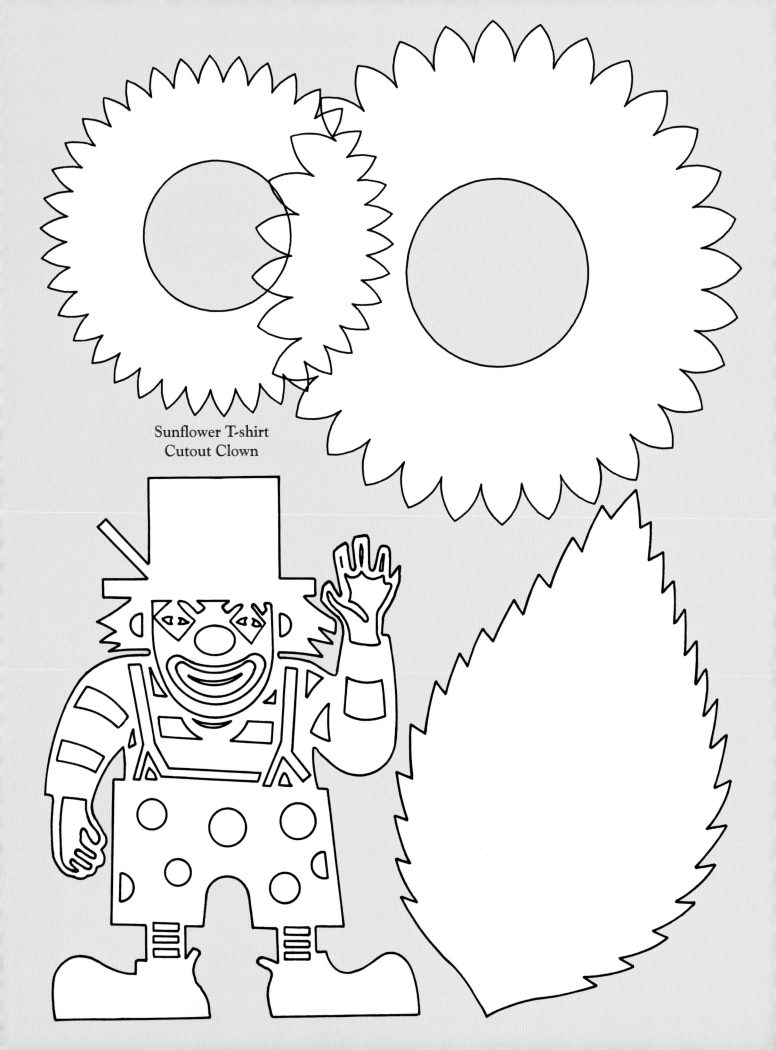

Sunflower T-shirt
Cutout Clown

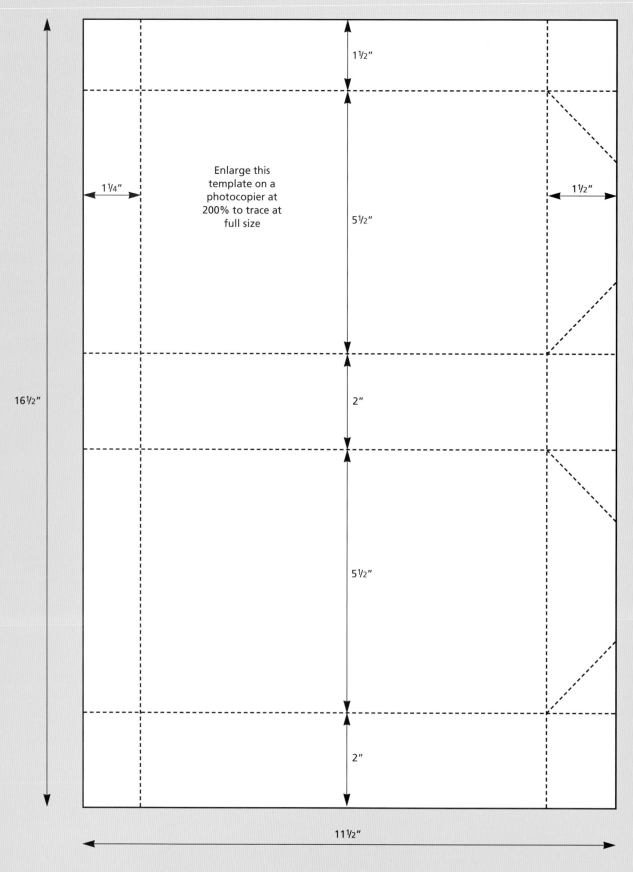

1½"

1¼"

1½"

Enlarge this
template on a
photocopier at
200% to trace at
full size

5½"

16½"

2"

5½"

2"

11½"

Bubble Bag

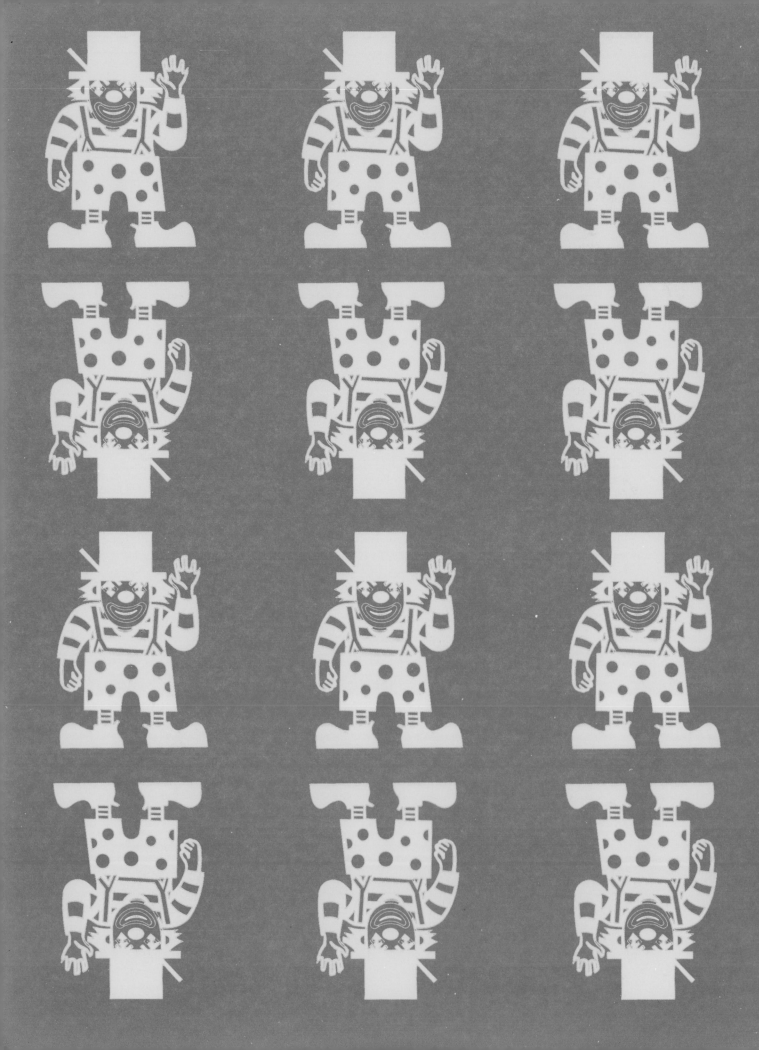